Jacques-Louis David

THE FAREWELL OF
TELEMACHUS AND EUCHARIS

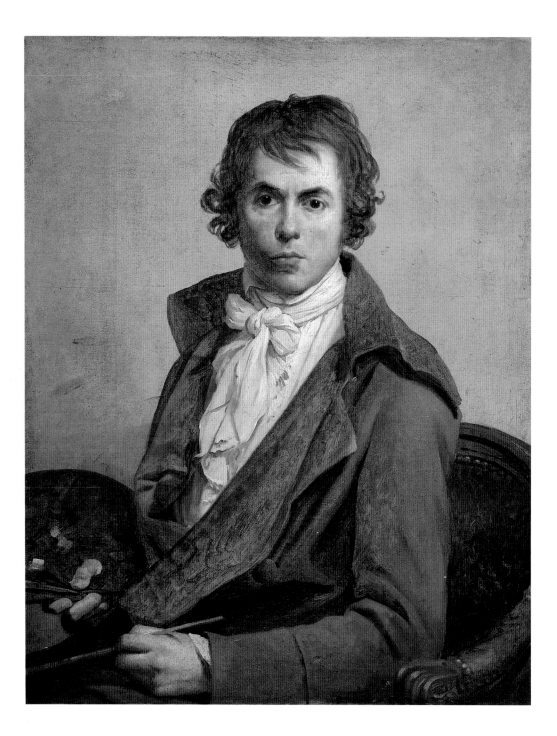

Jacques-Louis David

THE FAREWELL OF TELEMACHUS AND EUCHARIS

Dorothy Johnson

GETTY MUSEUM STUDIES ON ART

LOS ANGELES

For my parents, Alice and John Winter, and for Johnny

Christopher Hudson, *Publisher*
Mark Greenberg, *Managing Editor*

Benedicte Gilman, *Editor*
Elizabeth Burke Kahn, *Production Coordinator*
Jeffrey Cohen, *Designer*
Lou Meluso, *Photographer*
 (Getty objects, 87.PA.27, 86.PA.740)

Library of Congress
Cataloging-in-Publication Data

Johnson, Dorothy.
 Jacques-Louis David, the Farewell of
 Telemachus and Eucharis / Dorothy Johnson.
 p. cm.—(Getty Museum studies on art)
 Includes bibliographical references (p. –).
 ISBN 0-89236-236-7
 1. David, Jacques Louis, 1748–1825. Farewell
 of Telemachus and Eucharis. 2. David, Jacques
 Louis, 1748–1825 Criticism and interpretation.
 3. Telemachus (Greek mythology)—Art.
 4. Eucharis (Greek mythology)—Art. I. Title.
 II. Series.
 ND553.D25A66 1997
 759.4—dc20 94–23806
 CIP

Cover:
Jacques-Louis David (French, 1748–1825).
The Farewell of Telemachus and Eucharis, 1818
(detail). Oil on canvas, 87.2 × 103 cm (34⅛ × 40½ in.).
Los Angeles, The J. Paul Getty Museum (87.PA.27).

Frontispiece:
Jacques-Louis David. *Self-Portrait*, 1794.
Oil on canvas, 81 × 64 cm (31⅞ × 25¼ in.). Paris,
Musée du Louvre (3705). © Photo R.M.N.

All works of art are reproduced (and photographs
provided) courtesy of the owners, unless otherwise
indicated.

Typography by G & S Typesetters, Inc.,
Austin, Texas
Printed by C & C Offset Printing Co., Ltd.,
Hong Kong

CONTENTS

Final page folds out,
providing a reference color plate of
*The Farewell of
Telemachus and Eucharis*

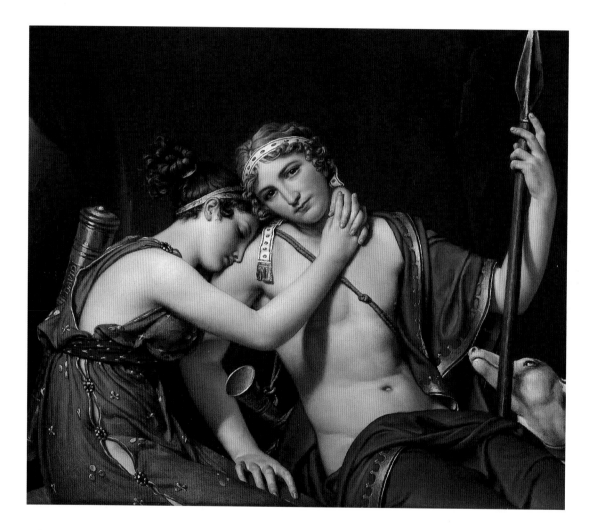

INTRODUCTION

In 1818 Jacques-Louis David (1748–1825) painted one of the tenderest and most lyrical compositions of his career, *The Farewell of Telemachus and Eucharis* [FIGURE 1, FOLDOUT], as a pendant to one of the strangest and most rebarbative works he had ever created—*Amor and Psyche*, 1817 [FIGURE 2]. While *Amor and Psyche* was decried by some observers as a revolting parody of adolescent love, one that reveals the monstrous, loathsome, and predatory nature of the libidinous adolescent male, *Telemachus and Eucharis* was hailed for being its antithesis, for depicting the innocence and purity of an adolescent couple who genuinely love one another and who tenderly embrace for the last time. It is easy to see why the original viewers of *Telemachus and Eucharis* praised it so highly. Using brilliant, deeply saturated colors reminiscent of those seen in medieval manuscript illuminations, David depicts the youthful, melancholy lovers at a moment of intimate farewell in the privacy of a dark cave. The sorrowful expressions of their faces and their harmonious, interlocking forms as they sit side by side reveal the depth and sincerity of their rapport. By representing the heartfelt love and friendship of the adolescent mythical couple, David was diverging radically not only from the literary sources that recount the narrative but also from visual precedents that emphasize a hopeless erotic attraction brought about by a malicious Cupid.

Eucharis does not appear in Homer's description of Telemachus's quest for his father in *The Odyssey*. She does, however, figure prominently in François de Salignac de La Mothe-Fénelon's tale of *Les Aventures de Télémaque* (1699), which was extremely popular in the eighteenth and nineteenth centuries and served as a principal source for pictorial versions of the theme during this period. In Fénelon's story, when, during his search for Odysseus, the youthful and handsome Telemachus is shipwrecked on the island of the enchantress Calypso, Cupid makes him fall hopelessly in love with the nymph Eucharis. The jealous Calypso prevents the two lovers from meeting alone, and Mentor, Telemachus's stalwart guide, craftily arranges to remove his youthful charge from the island so that the search

I

for Odysseus can continue. David completely transforms the nature and intent of Fénelon's didactic tale by inventing a moment in which the lovers *do* meet in private, and he emphasizes the psychological rapport of the saddened lovers who are about to part.

In his sympathetic portrayal David depicts what contemporary spectators hailed as the "chaste innocence" of the young couple, an aspect of the composition that held great appeal. Viewers of the time, in fact, interpreted this work in terms of human development and psychology. This is not surprising since in early nineteenth-century France myth had become revitalized as a dynamic cultural force. Myths were understood to be expressive of the human condition, revealing universal truths about human psychology and development and containing relevant messages for contemporary individuals and society.[1]

This renascence of myth began during the last decades of the eighteenth century. In the late eighteenth and early nineteenth centuries in France, a vast number of mythological studies were published in which myths were analyzed for their historical values and "truths" as well as for their psychological meanings. This burgeoning of the writings on myth, which gave birth to modern mythography (the study of myth as a "scientific" discipline), corresponded to a remarkable increase in representations of mythological themes in works exhibited at the Salons, the biennial exhibitions of paintings and sculpture held at the Louvre in Paris.

The sudden resurgence of interest in mythological subjects in French art at the end of the eighteenth century is nothing short of extraordinary. About 1750 the Académie Royale de Peinture et de Sculpture (Royal academy of painting and sculpture) had begun to denounce mythical themes in art as frivolous and unworthy and had inaugurated an antimyth movement that resulted in a significant diminution in the depiction of overtly erotic mythological subjects from the 1760s to the 1780s. It should not surprise us that David, the great innovator who had transformed history painting with his *Oath of the Horatii*, 1784–85 [see FIGURE 9], effected a revival of myth in French art. In 1789, when David presented a serious, psychological treatment of an amatory mythological subject—*The Loves of Paris and Helen* [FIGURE 3]—he offered an interpretation that differed significantly from those seen earlier in the century. At the height of academic reforms in the 1760s and 1770s, history painting, because it was considered moral and didactic, was pro-

2

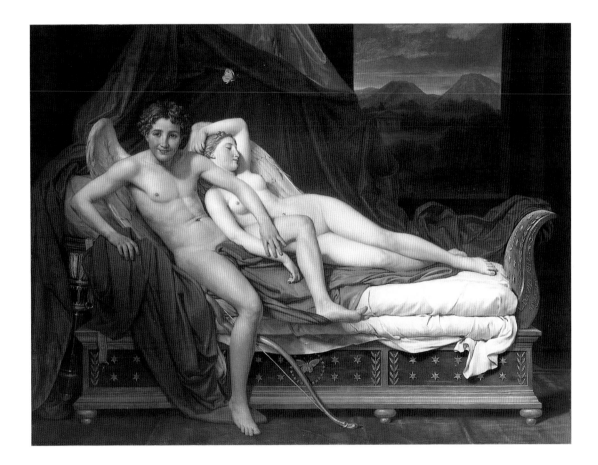

moted as the most valued form of serious, high art; the formerly popular, light-hearted, erotic celebrations of the loves of the gods and goddesses had come increasingly to be associated with the decadence and debauchery of court patrons who commissioned this type of work.

David, who had become renowned for his moral, didactic history paintings in the 1780s, surprised the public and critics when, at the low ebb of erotic mythological themes in French painting, he created *The Loves of Paris and Helen* and exhibited it at the Salon of 1789 alongside his very serious composition based on ancient Roman history, *The Lictors Returning to Brutus the Bodies of His Sons* [*see* FIGURE 11]. Although David depicts an amatory mythical subject in *Paris and Helen*, it is the very opposite of joyful and lighthearted. He presents us with a subdued and melancholy image of tragic lovers whose passion leads to the destruction of an entire civilization—the fall of Troy. His emphasis in this painting on the somber aspects of erotic love inspired his students and followers to represent erotical themes in a very serious manner and launched an extremely rich period in the representation of mythological subjects, which continued to be informed by the complexities and ambiguities of the psychology of love and the mysterious forces determining human sexual behavior.

While his contemporaries, both painters and sculptors, enthusiastically embraced the depiction of myths, David spent most of the periods of the Revolution and the Napoleonic Consulate and Empire engaged in representing other types of subjects, principally those from contemporary and ancient history (he created only one mythological painting during this time, *Sappho, Phaon and Amor*, 1809 [FIGURE 4], which was sent to a patron in Russia and remained virtually unknown to the French public). But, exiled in Brussels at the end of his life (1816–25), freed from many of the political, social, and aesthetic constraints of his native culture, he turned his full attention to the exploration of the mythical theme. In all his major paintings from the Brussels period, David reinterprets myth in ways that are often so remarkable or even astonishing that frequently a certain number of spectators in both Belgium and France—even those who praised the works as great masterpieces—were baffled by their meaning and simply did not know how to interpret these powerful and innovative compositions. (Responses to

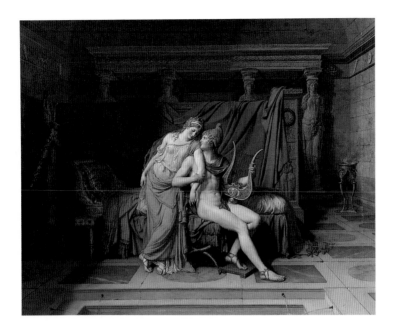

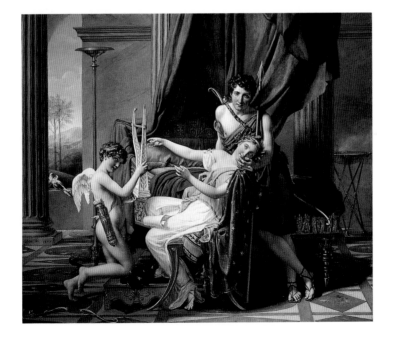

Figure 3
Jacques-Louis David.
*The Loves of Paris and
Helen*, 1787–89. Oil on
canvas, 146 × 181 cm
(57 ½ × 71 ¼ in.). Paris,
Musée du Louvre (3696).
© Photo R.M.N.

Figure 4
Jacques-Louis David.
*Sappho, Phaon and
Amor*, 1809. Oil on can-
vas, 224 × 262.5 cm
(88 ¼ × 103 ⅜ in.).
Saint Petersburg,
The Hermitage Museum.
Photo: Art Resource,
New York.

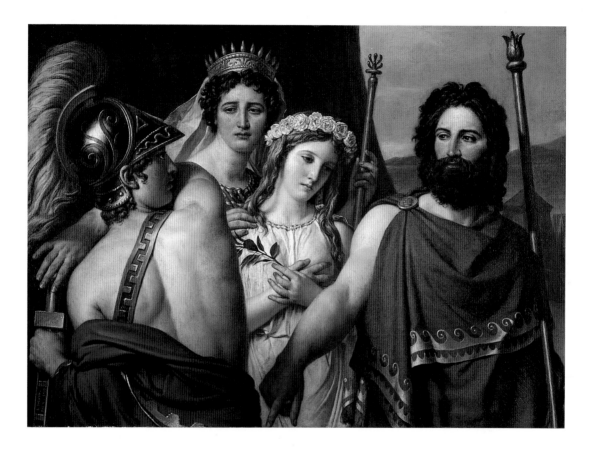

Figure 5
Jacques-Louis David. *The Anger of Achilles*, 1819. Oil on canvas, 105.3 × 145 cm (41½ × 57⅛ in.). Fort Worth, Texas, Kimbell Art Museum (AP 1980.07).

Figure 6
Jacques-Louis David. *Mars Disarmed by Venus and the Graces*, 1824. Oil on canvas, 310.6 × 264.4 cm (122¼ × 104⅛ in.). Brussels, Musées royaux des Beaux-Arts de Belgique (3261).

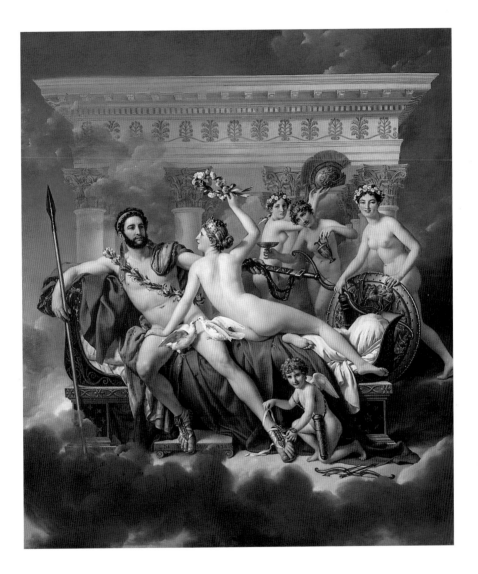

these compositions by David's contemporaries are discussed throughout this book whenever relevant.)

The Farewell of Telemachus and Eucharis, the best-received of these paintings, was the second of four major mythological paintings that David executed in Brussels. In 1817 he shocked even his most loyal students with his parodic and brutal Amor and Psyche, a work that debunked the mythology of love. Perhaps in response to some of the more severe criticisms of this composition, which even his most devoted disciple, Antoine-Jean Gros, found harsh and disturbing, David decided to create a pendant painting, one that would express the possibilities of a tender and gentle adolescent love (more will be said later about the relationship of these pendants). The poetic Telemachus and Eucharis thus served as an antidote to the heartless depiction of adolescent sexuality in Amor and Psyche. In 1819 David painted The Anger of Achilles [FIGURE 5], a work notable for its brilliant color, flattened corporal forms, and its pronounced emphasis on the problematics of family psychology and intense emotional expressivity of individuals. His final mythological painting done in Brussels, the stunning and monumental Mars Disarmed by Venus and the Graces, 1824 [FIGURE 6], a seriocomic work that subverts accepted conventions and norms by combining the parodic and the sublime, realism and idealism, constitutes his final aesthetic manifesto—it was the last painting he made before his death in 1825.

Elsewhere I have analyzed in some detail Amor and Psyche, The Anger of Achilles, and Mars Disarmed by Venus and the Graces.[2] Here the focus is on David's most lyrical and melancholy mythological masterpiece. In order better to understand The Farewell of Telemachus and Eucharis, it is necessary to examine it in a variety of contexts. This study will analyze the innovative iconography of Telemachus and Eucharis, which diverges so strikingly from literary and visual precedents, its position and relationship to David's remarkable corpus of works produced in Brussels, its contributions to the renascence and reinterpretation of myth during this period, and its very significant impact on subsequent mythological compositions made in the 1820s in Belgium and France. It is necessary to begin, however, with the historical background of David's exile in Brussels, an event that served as a catalyst to the final and most unexpected phase of his career.

FREEDOM IN EXILE

On January 27, 1816, Jacques-Louis David arrived in Brussels with his wife, Charlotte. At the age of sixty-eight he was banished by French law, exiled from France for having voted for the death of Louis XVI during the French Revolution and for later swearing fidelity to Napoleon during the Hundred Days by signing the *Acte additionnel aux Constitutions de l'Empire*. This law had come into effect almost immediately after Napoleon's fall and the return of the Bourbon monarchy to France in the person of Louis XVIII.

In his new home in Belgium, David associated with a large number of exiles—regicides and other French political refugees. But the artist whose name had so often been associated with the representation of political themes and events, first during the Revolution and then during the Empire, would at the end of his life look to significantly new directions in his art. His years of exile, from 1816 to his death on December 29, 1825, witnessed an intense outpouring of creative energy.

In Brussels David produced many of his most complex and innovative works. He also painted a great number of portraits in a striking plurality of styles [*see* FIGURES 25, 26], his only extant genre painting [*see* FIGURE 24], and a vast group of drawings, which he conceived of as independent, self-contained compositions rather than as studies for larger works, and which he often gave as gifts to friends [*see* FIGURES 21, 22, 23, 42, 44, 45]. This stunning corpus of works, impressive in its great variety of subjects as well as in its compositional, stylistic, technical, and interpretive innovations, constitutes a daring new direction in David's art, an art that had always been characterized by continual metamorphoses and been informed by the very principle of transformation.

Until very recently, David's late works had been neglected and largely misunderstood because they differed so greatly from the canonical works with which he had traditionally been associated. The historiographers of the nineteenth and twentieth centuries repeatedly acclaimed and studied what they identified as David's major masterpieces, *Belisarius*, 1781 [FIGURE 7]; *Andromache Mourning*

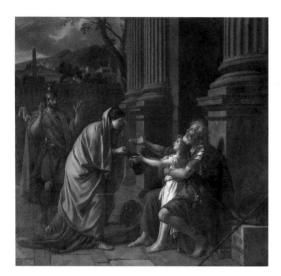

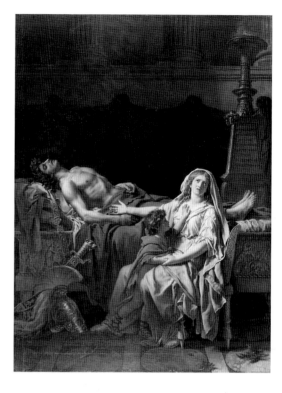

Figure 7
Jacques-Louis David.
Belisarius, 1781. Oil on
canvas, 290.7 × 315 cm
(114½ × 124 in.). Lille,
Musée des Beaux-Arts
(436).

Figure 8
Jacques-Louis David.
*Andromache Mourning
Hector*, 1783. Oil on
canvas, 227.2 ×
201.1 cm (89½ ×
79⅛ in.). Paris, Ecole
nationale supérieure
des Beaux-Arts.
© Photo R.M.N.

Hector, 1783 [FIGURE 8]; *The Oath of the Horatii*, 1784–85 [FIGURE 9]; *The Death of Socrates*, 1787 [FIGURE 10]; *The Lictors Returning to Brutus the Bodies of His Sons*, 1789 [FIGURE 11]; *The Death of Marat*, 1793 [FIGURE 12]; *The Sabine Women*, 1799 [FIGURE 13]; *Bonaparte Crossing the Saint-Bernard*, 1800 [FIGURE 14]; *The Coronation of Napoleon and Josephine*, 1805–7 [FIGURE 15]; and *Leonidas at Thermopylae*, 1814 [FIGURE 16], while either ignoring or denigrating the great works he produced in exile at the end of his life.[3] What can account for the neglect of such an important period of the artist's career? First we need to remember that a certain prejudice prevailed concerning the Brussels works because they were not painted in France. David no longer had the political influence and social status he had enjoyed as founder of the modern French school of art, painter and pageant master of the Revolution and the Republic and, subsequently, as "First Painter of the Emperor" (Napoleon appointed him to this position on December 18, 1804, two weeks after the coronation). Another reason, perhaps an even more potent force in shaping

and directing the historiography, is that the works David created in Brussels diverged radically from the "Davidian" style he had created earlier in his career, and therefore historians did not know how to assimilate the late works into the corpus of David's paintings from the 1780s to approximately 1814.

If one compares the artist's first great masterpiece, *The Oath of the Horatii*, 1784–85 [FIGURE 9], with his final aesthetic manifesto, *Mars Disarmed by Venus and the Graces*, 1824 [FIGURE 6], it is immediately evident that we are in completely different worlds. In *The Oath*, David depicts a moment of civic and moral heroism taken from Roman history in a composition characterized by a severity of

Figure 9
Jacques-Louis David.
The Oath of the Horatii,
1784–85. Oil on canvas,
330 × 425 cm (129 7/8 ×
167 3/8 in.). Paris,
Musée du Louvre (3692).
© Photo R.M.N.

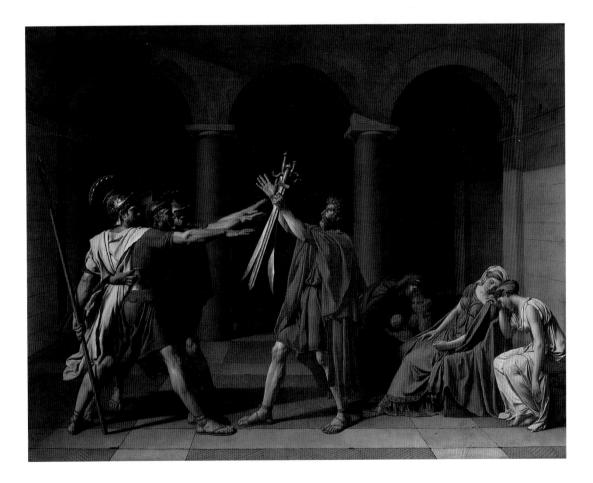

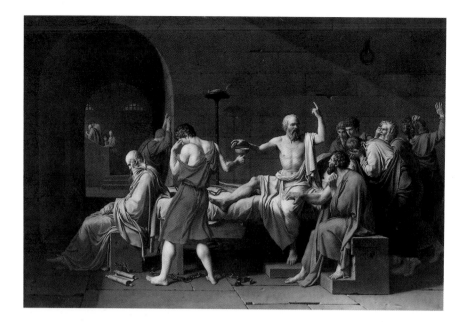

Figure 10
Jacques-Louis David.
The Death of Socrates,
1787. Oil on canvas,
129.5 × 196.2 cm
(51 × 77¼ in.). New
York, The Metropolitan
Museum of Art,
Wolfe Fund, 1931.
Catharine Lorillard Wolfe
Collection (31.45).

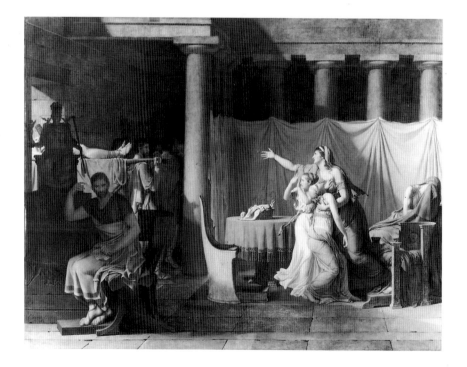

Figure 11
Jacques-Louis David.
*The Lictors Returning to
Brutus the Bodies of
His Sons*, 1789. Oil on
canvas, 325.9 × 425.9
cm (128¼ × 167¾ in.).
Paris, Musée du Louvre
(3693). © Photo R.M.N.

Opposite:
Figure 12
Jacques-Louis David. *The
Death of Marat*, 1793.
Oil on canvas, 163.5 ×
126 cm (64⅜ × 49⅝
in.). Brussels, Musées
royaux des Beaux-Arts de
Belgique (3260).

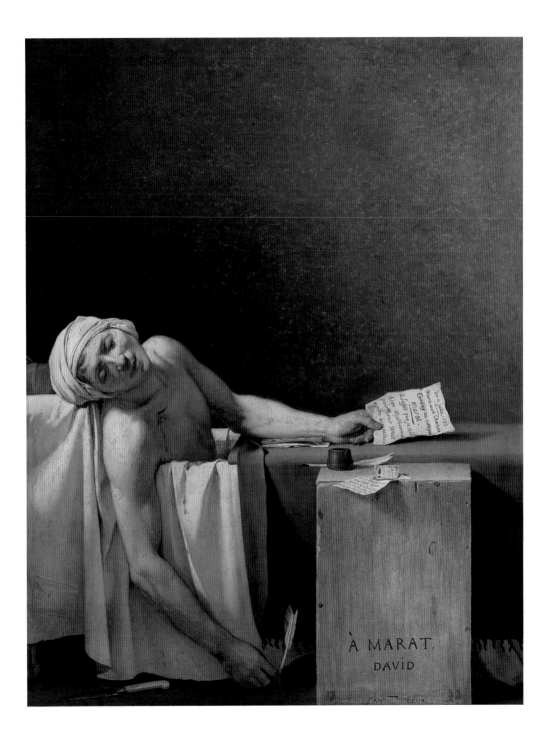

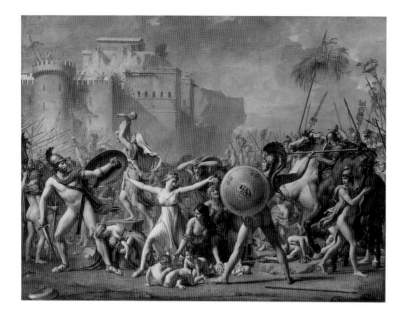

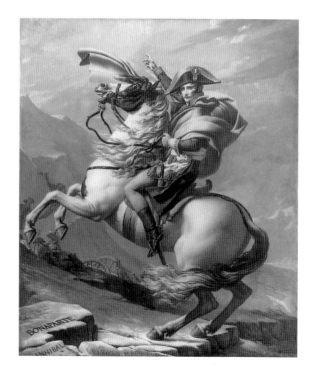

Figure 13
Jacques-Louis David. *The
Sabine Women*, 1799.
Oil on canvas, 390.7 ×
525 cm (153 7/8 × 206 3/4
in.). Paris, Musée du
Louvre (3691).
© Photo R.M.N.

Figure 14
Jacques-Louis David.
*Bonaparte Crossing the
Saint-Bernard*, 1800. Oil
on canvas, 273.4 × 234
cm (107 5/8 × 92 1/8 in.).
Rueil-Malmaison, Musée
National du Château de
Malmaison (MM-49-7-1).
© Photo R.M.N.

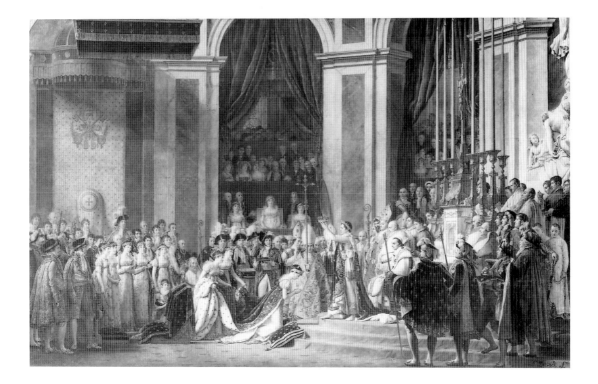

Figure 15
Jacques-Louis David. *The Coronation of Napoleon and Josephine*, 1805–7. Oil on canvas, 615 × 940 cm (242⅛ × 370⅛ in.). Paris, Musée du Louvre (3699).
© Photo R.M.N.

style and the imposing impact of the starkness of corporal forms. In *Mars Disarmed by Venus and the Graces*, he represents an erotic mythological theme noteworthy for brilliance of color, richness and luxuriance of textures and forms, translucency of skin, and a disturbing ambiguity of meaning; unlike the moral severity and seriousness of *The Oath*, this painting is comic and parodic as well as erotic. How could the David who launched his career as an independent artist with *The Oath* have concluded it with a painting that might be considered its diametrical opposite? In order to answer this question, we need to look very briefly at the development of the artist's career before he went into exile in Brussels.

DAVID'S CAREER IN FRANCE

David had begun his career by excelling as a student at the Académie Royale de Peinture et de Sculpture, which he had entered in 1766. In 1774 he won the highly

Figure 16
Jacques-Louis David.
Leonidas at Thermopylae,
1814. Oil on canvas,
398 × 536 cm (156¾ ×
211 in.). Paris, Musée
du Louvre (3690).
© Photo R.M.N.

competitive and prestigious Prix de Rome for his painting of *Antiochus and Stratonice*. This prize afforded him an extended fellowship period at the French Academy in Rome (1774–80), where he continued his artistic education. He returned to Paris in 1780 and launched his career by exhibiting the monumental history painting *Belisarius* in the Salon of 1781.

For most of his career, David created monumental history paintings associated with the *exemplum virtutis*—he celebrated the heroic, virtuous deeds of famous individuals from Greek and Roman history (during the Revolution and the Empire, he extended this mode to include the representations of the great individuals and great deeds of contemporary history). *The Oath of the Horatii* provides the perfect embodiment of the very popular theme of self-sacrifice and virtue. We witness Horatius, who has his sons swear on the swords he holds up to fight to the death to defend Rome against Alba. Only one son will return alive, but he will be triumphant—the city of Rome will endure. Personal and private life, the family and the self, are sacrificed for the greater good of the country, the civic cause. The women of the family realize the implications of this fervent oath, for they sit sorrowfully on the opposite side of the room, overcome with the burden of grief and loss that such civic decisions portend. From the period of the first exhibition of *The Oath*, critics had praised the contrast David created between the stark, angular, muscular forms of the male figures and the soft, round, curved, collapsing forms of the female figures. The male and female realms as they had been defined in eighteenth-century French society—the world of decisive action versus that of passive acceptance—are separated by a void.

The Oath of the Horatii perfectly embodies a principal direction of late eighteenth-century French painting, for such subjects had been strongly promoted by the Académie Royale since the 1750s; the representation of heroic deeds from antiquity was seen as an essential part of late eighteenth-century academic reforms, which sought to purge French art of what had been described as the frivolity and lasciviousness of mythological themes, especially the depiction of the loves of the gods and goddesses. These amatory subjects were a favorite theme of academic court painters, whose works were supported by the king and the aristocracy during the first half of the eighteenth century. Some of the most appreciated

compositions were notable for a blatant eroticism. François Boucher immediately comes to mind as one of the most celebrated and influential of these artists—his *Hercules and Omphale*, about 1731–34 [FIGURE 17], provides a typical example of this type of painting. But during the 1760s, 1770s, and 1780s the depiction of mythical love themes came to be associated with the "degenerative" tastes of the elite ruling class. Important figures at the Académie Royale, such as the Directeur Général des Bâtiments, began commissioning works that represented themes of moral virtue, principally taken from Greek and Roman history.[4] Many such representations of virtue preceded *The Oath of the Horatii*, but in his first great masterpiece, David not only represented a theme that perfectly embodied the prevailing ideals of self-sacrifice and civic virtue but also created powerful figures whose compelling corporal presences exerted an immediate, visceral impact on the spectator; critics of the time acclaimed the painting for its remarkable "truth" in the depiction of the body, for an anatomical naturalism and convincing representation of volumes and forms through the expression of powerful contours that had not been seen in French painting earlier in the century. They also hailed its stunning, eloquent pantomime that made the meaning of the narrative instantly accessible as well as the exquisite treatment of the extremities—they noted that the hands and feet were depicted with an extraordinary and uncanny intensity. In *The Oath*, in fact, the body itself became the principal vehicle of communicating meaning, while facial expression played a very subdued and minor role. Up until *The Oath*, academic theory and practice dictated that physiognomy constituted the principal key to revealing narrative in painted and sculpted representation. This would all change dramatically as a result of David's painting.[5]

 The Oath of the Horatii transformed the making of painting in France, for immediately many artists tried to emulate the new compositional and stylistic effects seen in this work, especially in the depiction of the human figure, and it was used by critics as a standard by which subsequent paintings were judged for decades to come. With *The Oath*, David had firmly established himself as the leader of the new school of modern French painting. He attracted a vast number of students and became the most important and powerful artist in France as well as the best-known artist in Europe.

By the time of the French Revolution, David's reputation had reached new heights. It was during the period from approximately 1789 to 1794 that his name became associated with politics. David was imprisoned twice after the fall of Robespierre, in 1794 and again in 1795, and for a time he was in danger of being guillotined for his political involvement. As a fervent Republican, who, according to the testimony of his students and friends, never relinquished his Republican ideals, David was an active participant in the politics of the Republic. From 1792 to 1794 he was a deputy to the Convention, and he played a major role on two committees—the Committee of Public Instruction and the Committee for Public Security. As a result of his political activism, David was able to exert a considerable influence on the arts, and he worked for the establishment of the new museum (what would become the Musée du Louvre), for the creation of Revolutionary architectural and sculptural monuments, for the restoration of buildings and gardens, and for governmental support of artists through commissioned works during a period of great fiscal crisis. He also organized the Revolutionary festivals that took place in Paris—vast scenographic parades that celebrated Republican ideals and that were carefully orchestrated around symbolic sites. David created special costumes, emblems, reliefs, and other types of decor for these parades—in some cases he even designed temporary sculptural monuments.[6]

During this period of intense political activity, it is not surprising that David's major projects involved the commemoration of the great individuals and great deeds of the Revolution. In his completed sketch for *The Oath of the Tennis Court*, exhibited in 1791 [FIGURE 18], a monumental project that he never completed due to the tumultuous changes in political events, David celebrates the dramatic moment when 629 citizens, principally members of the Third Estate (the people), led by the mayor of Paris, assemble in the king's tennis court at Versailles and take an oath that they will remain united as a group until a constitution is created. Here David commemorates in a very dramatic fashion (a strong wind blows outside, agitating the draperies as lightning strikes the king's chapel) a momentous event of civil and moral virtue from contemporary history, a moment he deemed as the most significant in terms of the values and goals of the French Revolution.[7] David wanted to commemorate for posterity the hundreds of dedicated citizens who through this oath transcended their status in life and became heroic.

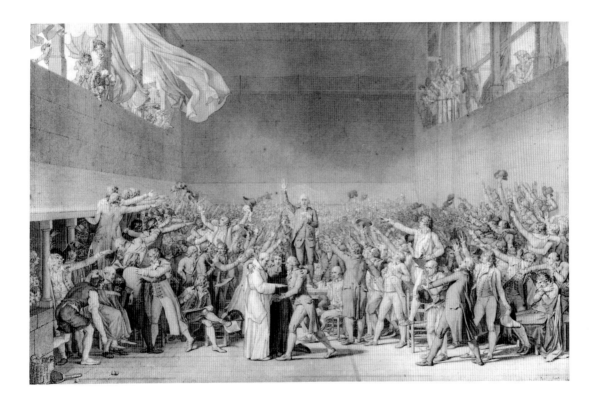

Figure 18
Jacques-Louis David.
The Oath of the Tennis Court, 1791. Pen washed with highlights of white on paper, 66.7 × 106 cm (26¼ × 41¾ in.). Versailles, Musée National du Château (MV 8409, des. 736).
© Photo R.M.N.

The artist's best-known works from this period, however, are his depictions of the Revolutionary martyrs—*Lepelletier de Saint-Fargeau*, 1793 [FIGURE 19]; *Marat*, 1793 [FIGURE 12]; and *Bara*, 1794 [FIGURE 20]. His representation of Marat has become an icon of the French Revolution. David's painting shows Marat, the self-proclaimed "friend of the people" who exposed "traitors" of the Revolution in his journal, immediately after he was stabbed to death in his bathtub by Charlotte Corday in 1793. The artist imagines *Marat at His Last Breath* (his original title of the painting) assassinated in the act of writing an *assignat* guaranteeing financial support for a poor widow and her children. David idealizes and makes heroic the features and form of the hero who died for the cause of his Revolutionary ideals. (Marat took baths because he suffered from a terrible skin disease that disfigured him—but there is no reference at all to this horrible condition in David's painting, nor to the uncomely features of Marat's face as it is known from descriptions and engravings of the time.) Although the figure and face of Marat are idealized, the meaning of the painting remains ambiguous, for David depicts Marat in a bathtub soaking in his own blood—an allusion to the literal bloodbath he promulgated with his mighty pen (the pen in his hand is placed adjacent to the bloody knife on the floor, the instrument of Marat's death).

In addition to his great political paintings and his involvement with the organization of the arts, David also worked very actively during the early 1790s to abolish the Académie Royale de Peinture et de Sculpture and replace this rigid, hierarchical institution that embodied the goals and values of the ancien régime with a more flexible structure that would nurture and encourage the arts in France. He and a group of artists who had rebelled against the Académie Royale succeeded in having it abolished by government decree in August of 1793. By 1795 the academy was replaced by the somewhat more open *Institut*, which nevertheless incorporated many of the former hierarchical structures and goals within its new organization. For many years, David played a major role at the *Institut* and thereby continued to exert a very powerful influence on the making and teaching of art in France.

As a direct and immediate result of his political difficulties due to his role in Revolutionary politics, and specifically his support of Robespierre, David eschewed the representation of contemporary political events in his paintings after his arrests in 1794 and 1795 and returned to powerful, moral themes from ancient

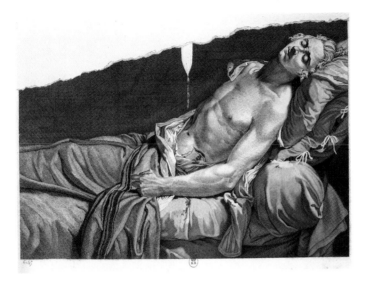

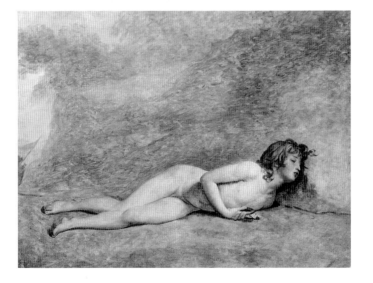

Greek and Roman history, his former sources of inspiration. He began *The Sabine Women* [FIGURE 13] while first imprisoned in 1794, completed it at his own expense (it was not a commissioned work), and in 1799 exhibited it in a large atelier in the Louvre. From 1799 to 1804 a vast number of people paid to view the monumental painting, which marked yet another new direction in David's art in terms of theme as well as compositional and stylistic transformations. The painting depicts a dramatic moment in the history of the foundation of Rome. The Romans had abducted, married, and had children with the Sabine women. When the Sabine armies came to rescue the women and clashed with the Romans in front of their emergent city, the Sabine women, now Roman wives and mothers, rushed onto the battlefield with their children and attempted to stop the internecine war. In the foreground of David's painting, represented in the style of a sculpted relief, we observe Hersilia, wife of the Roman leader, who heroically stands between her husband, Romulus, and her father, Tatius, whom Romulus is about to attack. The movement of these three central figures is suspended, time stands still, as if to mark a turning point in the development of Western civilization when the fate of Rome, of the family, and, by extension, of society hangs in the balance. As a result of the intervention of the courageous Sabine women the battle will end; reconciliation is at hand.

Although David's pendant for *The Sabine Women—Leonidas at Thermopylae* [FIGURE 16]—is characterized by renewed compositional and stylistic innovations, it nevertheless explores the theme of civilization and how the fate of a society depends on the heroic decisions and deeds of a single great individual. In this somber work, the artist depicts Leonidas, King of the Spartans, seated, meditating on the doom of his select army of three hundred men who will defend the pass at Thermopylae against the invasion of six hundred thousand Persians. Leonidas's decision to make a stand at the pass, knowing that he and all of his men will perish, constitutes the turning point in the Persian War and ensures ultimate triumph for the Greeks. Thus, Greek civilization is saved and the future of Western civilization is assured.

David began the *Leonidas* around 1799, but he did not complete and exhibit the work until 1814, for he was constantly interrupted by Napoleonic commissions throughout the periods of the Consulate and Empire. These commissions

signal the beginning of his return to the depiction of political themes based on contemporary events. In 1800, during the Consulate, David executed a major monumental equestrian portrait of *Bonaparte Crossing the Saint-Bernard* [FIGURE 14] that celebrates the victorious campaign at Marengo. David depicts a powerful and compelling Bonaparte on a rearing stallion in an alpine landscape. At a heroic, visionary moment, Bonaparte points his army ahead to the victory that lies on the other side of the mountain. The composition is metaphorical and emblematic, for David depicts Bonaparte's leadership of his army and, by analogy, of the French nation. Inscribed on the rocks beneath the horse's hooves are the names of Bonaparte's illustrious and victorious predecessors who, like him, founded empires on military might—Hannibal and Charlemagne.

On December 18, 1804, when Napoleon named David "First Painter of the Emperor," he had already commissioned him to execute a series of four monumental paintings commemorating the ceremonies that inaugurated the Empire. Only two were completed—*The Coronation*, 1805–7 [FIGURE 15], and *The Distribution of the Eagles*, 1810. Of these, *The Coronation* is by far the more successful in terms of its brilliant compositional solutions to the very difficult problem of representing a monumental pageant (*The Distribution of the Eagles*, which I have analyzed at length elsewhere, is a complex and politically subversive work characterized by unexpected and unusual compositional devices). In *The Coronation*, David depicts a vast number of life-size or nearly life-size figures in the transept crossing of the Cathedral of Notre Dame in Paris at the moment when Napoleon created his Empire by crowning himself and his wife, Josephine, Emperor and Empress, while Pope Pius VII, a political prisoner brought to Paris from Rome against his will, reluctantly blessed the event. David realized that the coronation constituted a pivotal moment in French history, for in the act of crowning himself Emperor, Napoleon brought to an end the ideologies of the Revolutionary governments of the 1790s and reinstituted a monarchy that drew upon former structures of Church and state.

Although the viewer may be distracted by the splendor of costume and lavishness of detail, the metaphorical meaning of the painting is direct. David represents the reinstatement of the Three Estates of the ancien régime—the king and court, the clergy, and the people—in a hierarchy of values based on the pre-

Revolutionary structures of French society. The new monarch and his court take up most of the foreground space from left to center, with the clergy to the far right grouped around the main altar of the Cathedral of Notre Dame. The middle classes and the remaining constituents of the Third Estate observe the ceremonies from the distant upper tiers—they are literally in the shadows and are represented in a very sketchy, abbreviated manner. Their elevated position in the tiers, thus, no longer reflects the temporary elevation of their status attained during the Revolution. They may observe from above, but they appear colorless and insignificant. The "people" are no longer the principal players in the French state.

With the Napoleonic commissions, David had much less artistic freedom, for the subjects and content of the commissioned paintings were negotiated with Napoleon and his ministers, and even up until the last moment Napoleon insisted that changes be made in the monumental compositions (the metaphorical meanings of the works, which often had strongly negative political and social resonances, were usually not understood by the emperor and his advisers). We know from a series of letters and manuscript notes that David endured a number of personal and political problems and setbacks during Napoleon's regime. He fiercely resented the changes in his paintings imposed by Napoleon and his ministers, and, in addition, he had serious difficulties getting paid for the commissions.[8] David also continued to suffer from the machinations of the powerful enemies he had made in art and politics as a result of his role in the Revolution. Resentful and jealous colleagues worked to thwart his rapport with the emperor and to undermine and subvert David's position of power in directing the arts. Fortunately, David was surrounded by devoted students (many of whom had become famous artists themselves, such as Antoine-Jean Gros) who gave him much needed support and encouragement in times of terrible stress and difficulties.

DAVID IN BRUSSELS

Looking back on his life from his vantage point in Brussels, David summed up his entire career in France as one beset by continual conflicts and difficulties. This was not a new view that he suddenly developed, but rather, it constituted a recurrent theme in his letters and comments to students, family, and friends from the very

beginning of his career in Paris and Rome in the 1770s and 1780s up until and continuing through his exile. One of the principal themes of David's letters written in exile was his insistence on a new type of tranquility that he enjoyed, freed from the political, social, and artistic pressures that he had endured throughout his entire career in France. In his first letter from Brussels, written to his aunt and uncle, the Burons, on January 29, 1816, David announced his intention to enjoy the peace of the meditative life that his new situation afforded him:

> We are living in a very hospitable city in which, as far as I can see,
> I will find all the amenities of society. But I will abstain from them
> as much as I can. As you know, I like the contemplative life, and I
> want to give myself up to it here more than elsewhere.[9]

In his letters and notes, in reported conversations and statements made in his wife's letters, David repeatedly reiterated that he had found a peace and tranquility in Brussels that he had never known before: "I am doing well here, I am happy here, I set eyes on no one who bothers me."[10]

David spoke very warmly of the hospitality he had received in Brussels and praised King William of the Low Countries, who so generously received him. He turned down opportunities to be a more active and vital political and artistic force. In the spring of 1816, for example, the king of Prussia invited David to move to Berlin and become the new Director of the Arts. David declined—he said he would stay where he was, concentrate solely on his art, and thereby try to realize the new ideas he had for monumental compositions as well as for works in other genres.[11] Resisting the efforts of his family, students, and friends, David also refused to make any overtures to the new French king, Louis XVIII, which would have enabled him to return to France. He did so out of principle, for he declared that he would not retract his actions during the French Revolution, especially his vote for the death of the king. On January 1, 1819, he wrote the following to his son Eugène:

> All of my colleagues are returning to France. I would certainly be
> among them if I were weak enough to ask for my reinstatement in
> writing. You know your father and the pride of his character.

Could he make such a request? I knew what I was doing; I was old enough to know what I was doing. I did not do it in the heat of passion. Time will unveil the truth. . . . Here I can rest.[12]

David also spoke of the persecution he had suffered in France from the very beginning of his career in an eloquent letter to Gros of November 2, 1819:

We will never understand one another, my friend, as long as you will be persuaded that one can be happy only in France. I am myself inclined to think the opposite. Since my return from Rome, in 1781, I have not ceased to be persecuted and tormented in my work by all the most odious means possible, and if the heavens had not favored me with a certain obstinacy, I would have succumbed to it. Let me enjoy in peace the tranquility that I experience in this country and that was unknown to me up until now.[13]

David particularly enjoyed the artistic freedom that exile afforded him—it provided him with an intellectual and psychological perspective that allowed his imagination free reign. In addition, he was at the height of his powers artistically—his works created in exile, brilliant in both conception and execution, attest to this. And he believed that he could still exert an important impact on French art, even though he was no longer present in Paris as a powerful figure of artistic authority. He was prevented from exhibiting at the Paris Salons, but he did make concerted efforts to have several of his monumental mythological compositions shown in Paris (all were exhibited first in Belgium, to great acclaim). He was extremely successful in this quest, for his works exhibited in Paris generated a great deal of curiosity and excitement—there was understandably much speculation about this great French celebrity, the exiled founder of the modern French school.

Two paintings, in particular, *Amor and Psyche*, 1817 [FIGURE 2], and *Mars Disarmed by Venus and the Graces*, 1824 [FIGURE 6], astonished the large number of spectators who saw them in Paris. The dramatic and unexpected transformations in subject, composition, and style inspired lengthy responses in the French press, and David's students, family, and friends in Paris wrote him their reactions as well.[14] Thus, even though in exile, David remained in close contact with people

in Paris, principally through letters and visits from family, students, and friends. And we must also remember that he was surrounded in his daily life by French friends and acquaintances who, like him, lived in exile in Belgium (a country in which French was the principal language). He therefore continued to be immersed in a French milieu, reflecting upon his life and career in France even as he created works that heralded completely new directions in his art. On July 3, 1819, David wrote to the mayor of Brussels: "These works are the fruit of a tranquility of spirit that I share with the happy inhabitants of this empire." [15]

An overview of the great range and variety of works David created in Brussels reveals the intensity of the artist's mind and imagination as well as his great technical and stylistic experimentation and mastery. In spite of bouts with several serious illnesses, culminating in fatal heart failure on December 29, 1825, David worked feverishly and constantly. He executed drawings, apparently on an almost daily basis [FIGURES 21, 22, 23, 41, 42, 44], works that he considered independent compositions, many of which were destined to be given to friends; he invented a very unusual genre scene [FIGURE 24], thereby embracing a category of painting he had previously virtually eschewed; he painted many portraits, most of which are life-size and constitute great masterpieces [FIGURES 25, 26]; he produced a monumental repetition of *The Coronation of Napoleon and Josephine*, which offers significant variations from the original, and he created four monumental mythological paintings [FIGURES 1, 2, 5, 6], which, we know from his letters, notes, and comments to family and friends, he considered to be among his greatest masterpieces, and which were intended to embody and express his final artistic ideas. All of these works represent dramatic new directions in David's art.

Before we focus on one work in particular—his beautiful and eloquent *Telemachus and Eucharis*—it will be helpful to look at the important context in which this work was created, namely, the body of works David produced in Brussels, all of which are interrelated in terms of informing ideas and new aesthetic objectives.

David's corpus of drawings is the most fascinating and problematic part of all of his Brussels production. We are told that David worked incessantly on creating this very long series of small works, usually individualized bust-length representations of antique-looking figures presented in a portraitlike format. The

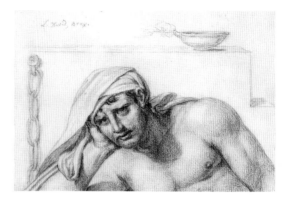

group comprises single figures, amorous couples, and groups, which have in common disquiet, anxiety, introversion, conflict, or unhappiness. David used the vehicle of drawings (which would be done very rapidly, and which therefore lent themselves to an immediate embodiment of the artist's insights and ideas) as a means of exploring states of psychic and emotional tension, ambiguous states that involve a complex nexus of emotions. The works are self-contained and neither intended as studies for larger compositions, nor commissioned. They therefore belong to the early nineteenth-century emergent category of the private or personal Romantic drawing—works not made for public exhibition but intended instead as part of the artist's personal explorations of emotions and ideas that he might share with family and friends. Most of David's Brussels drawings are enigmatic and compelling because their meanings are puzzling and obscure. The artist invites us to reflect upon the meaning, which will remain elusive and complex.

Many of David's late drawings depict states of isolation and introversion. Sometimes a summary narrative structure is appended as though to offer at least a small clue that would help explain the subjective state of suffering that the figure or figures experience. This is true, for example, of the beautifully executed and psychologically disturbing *Prisoner*, in which David engages the archetypal romantic theme of imprisonment [FIGURE 21]. As in most of his late drawings, David here represents an individual in the portrait format of the half-figure in the immediate foreground plane—a device that increases the directness and immediacy of the rapport between the viewer and the figure. We learn almost nothing

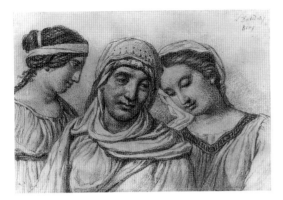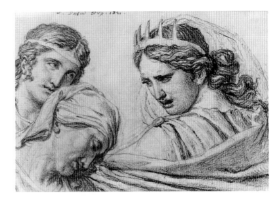

about the prisoner or his specific situation, but we are directly informed about his psychological state. The prisoner, appositely situated in a cramped and claustrophobic space, is chained to the wall behind him; he slumps on his right hand and elbow and looks out at us accusingly with lips parted as though he were about to speak. His face is troubled, filled with bitterness and consternation, and his powerful, broad, muscular upper body in conjunction with the expression on his face makes him appear menacing. We can only speculate on his crimes and character and the behavior that led to his imprisonment (having been imprisoned twice himself for political reasons, David would have had insight into this subject from personal experience).

The variety of subjects in his late drawings reveals that David sought to explore the great range and panoply of emotions inherent in the human condition. In other drawings he represents what appear to be familial relationships, presented, again, in the half-figure format of the portrait, with individualized figures located in the immediate foreground space for greater psychological impact. Two such drawings [FIGURES 22, 23], which appear related in theme, were presented in 1825, as part of a gift of four drawings, to Charles van Hutten, the president of the Société royale des beaux-arts et de littérature of Ghent. In one, dated 1817, an older woman in the center foreground inclines her head slightly and seems absorbed in thoughts that may have to do with the young girl to her right, perhaps her daughter, who pensively inclines her head toward her mother. The female figure to the left, perhaps another daughter, is also thinking, but although in close

Figure 22
Jacques-Louis David. *Three Women*, 1817. Black chalk on glued-down leaf, 13.5 × 19.5 cm (5¼ × 7⅝ in.). Ghent, Museum voor Schone Kunsten (1933-E1). © A.C.L., Brussels.

Figure 23
Jacques-Louis David. *Study of Three Heads*, 1821. Pencil drawing, 14.1 × 19.9 cm (5½ × 7⅞ in.). Denver, The Denver Art Museum (loan no. 1.1970), lent by Dr. Esmond Bradley Martin. Photo courtesy of The Denver Art Museum.

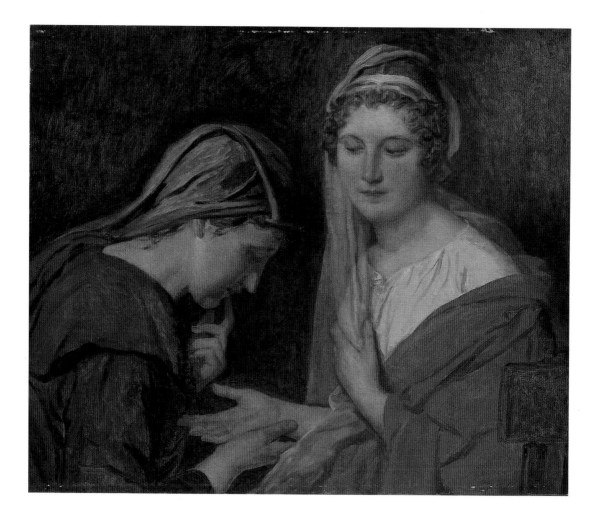

physical proximity, she is separated psychologically from the other two. David has achieved this through the position and direction of her figure. She is in profile and looks out behind the other two rather than incline toward them. She is also differentiated in style; she is an idealized, classical type, while the other two are particularized, modern-looking individuals. The costumes are vaguely classical looking, but we are given no specific clues as to time and place. As in most of David's drawings, there is no setting, no background, that would help provide a narrative. In the drawing dated 1821, we again see three figures, in a like format, but we witness here what appears to be a queen, wearing a sharply spiked crown, probably emblematic of her thorny personality, contemptuously yelling at an older woman who bows her head in sorrow and humiliation, while a third figure, unhappy witness to this conflict, looks askance at the sharp-tongued queen.[16]

These puzzling and problematic drawings, in which meaning is so difficult to determine, constitute a principal new direction in David's art in exile, one we find embodied in his only surviving genre painting (and one of only two he ever painted), *The Fortune Teller*, about 1824 [FIGURE 24]. David here brings to the realm of painting the style, format, and themes he had explored in his many drawings executed in exile. The painting is very sketchy, and its surface appears unfinished, incomplete. This lack of high finish, this seeming incompletion, may have to do with the meaning, which, as in the drawings, requires the imagination of the spectator to effect some kind of completion.

The fortune teller, a theme that appeared in late Renaissance and Baroque art, continued to be represented in eighteenth- and early nineteenth-century French art, although the subject was relatively rare. In this composition, David has done everything in his power to bring the figures into the most intense psychological focus possible. He has reduced the number of figures to two and isolated them from any setting whatsoever. The presentation of the large, half-length figures in the immediate foreground plane against a completely neutral background compels the spectator to attend exclusively to the psychological drama occasioned by chiromancy that is unfolding. The young gypsy appears puzzled by what she sees in the lines of the palm she examines, while her client, with pursed lips, appears anxious and worried about what the future may hold. David increases the impact on the viewer by using the format of the family portrait, a device he

Figure 24
Jacques-Louis David. *The Fortune Teller*, ca. 1824. Oil on canvas, 62 × 75 cm (24⅜ × 29½ in.). San Francisco, The Fine Arts Museums of San Francisco, Gift of David David-Weill (1947.3).

employs frequently in his Brussels compositions (including in the representation of *Telemachus and Eucharis*), and by using a recognizable model for the Roman matron—Victorine Frémiet, a good friend and sister of his pupil Sophie Frémiet.[17]

It should not surprise us that David would choose the format of the family portrait for so many of his compositions made in exile, for during this period he was very deeply involved with painting portraits, and these constitute some of his most brilliant and experimental Brussels works. One of the most striking of his family portraits is the group of *Zénaïde and Charlotte Bonaparte* [FIGURE 25], painted in 1821 and now in the Getty Museum.[18] Through the presentation of their forms, using corporal configuration, costume, and facial position and expression, David has subtly characterized the differences in character and temperament of the two sisters as well as their relationship to one another. The more sympathetic Charlotte, dressed in a modest, pale blue satin dress with a high lace ruff collar, sits shyly behind her sister, whom she gingerly embraces (David was very fond of her and had given her drawing lessons when the sisters visited Brussels). Charlotte appears to withdraw slightly, to retire. The forthright Zénaïde contrasts dramatically with her sister—attired in an elegant black dress that is daringly décolleté, she is enfolded by a brilliant red and yellow shawl. These striking, contrastive colors seem to accord well with her upright carriage and posture, which express a boldness of personality and complete confidence that her timid sister seems to lack. Zénaïde stares directly out at us, while Charlotte, who also engages our glance, inclines her head slightly and defers to her sister.

David alludes not only to the wealth of the sitters, manifest in their elegant clothing, but also to their former status as Napoleonic royalty—both former princesses wear diadems, and they are seated on a royal-red couch embroidered with the emblematic Napoleonic bees. In her left hand, Zénaïde holds a letter the girls have received from their father, Joseph Bonaparte (he had established himself and his family in America, but in the early 1820s the family spent time in Brussels). In this fascinating portrait, David has emphasized resemblance; he has tried to capture facial features and structure, with seemingly little attempt at idealization or amelioration of forms. Thus, one sitter is heavy, one is thin; both are plain, neither endowed with the "classical" features for which Napoleon Bonaparte had been renowned. The hardness and brittleness of the smooth, bright, highly polished,

Figure 25
Jacques-Louis David.
*Zénaïde and Charlotte
Bonaparte,* 1821. Oil
on canvas, 129.5 ×
100 cm (51 × 39⅜ in.).
Los Angeles, The
J. Paul Getty Museum
(86.PA.740).

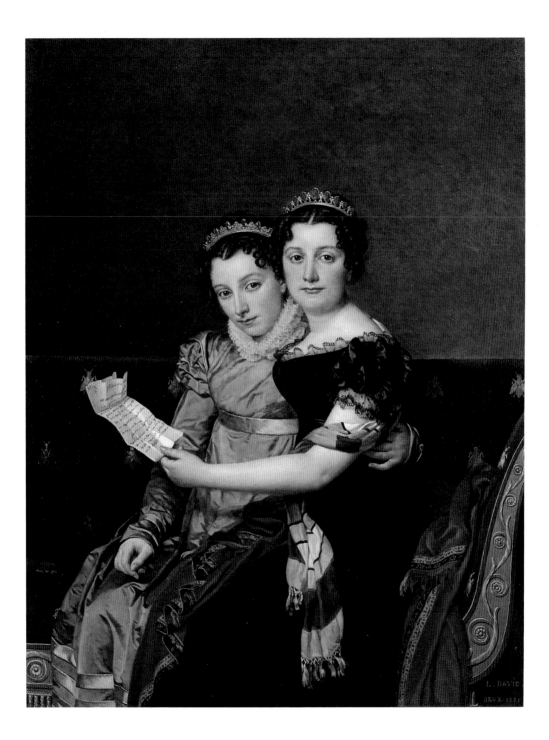

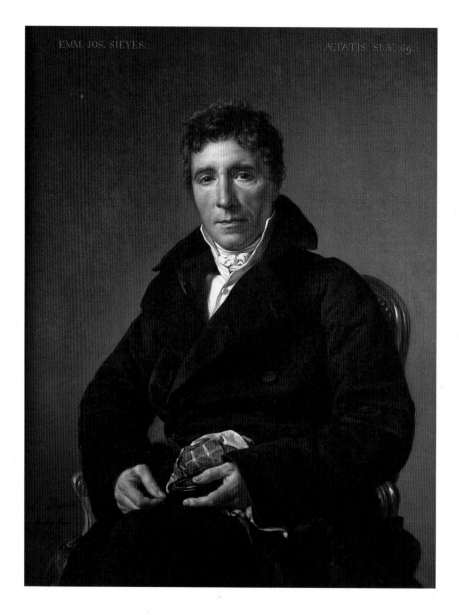

EMM. JOS. SIEYES. ÆTATIS SUÆ. 69.

enamellike surfaces, with no brushstrokes visible, are reminiscent of Jean-Auguste-Dominique Ingres's portrait style; they also help convey meaning—in fact, all details of composition and style serve to reveal temperament and character.

This was only one of the types of style that David employed in his Brussels portraits. He also painted in a soft, fluid style characterized by movement in broken surfaces, as in his magisterial representation of his friend, the former *conventionnel* and fellow regicide *Emmanuel-Joseph Sieyès*, 1817 [FIGURE 26], who, although sixty-nine years old, is depicted as a much younger man. (On several occasions David represented individuals at a much earlier moment in their lives, usually during a period in which they had made significant contributions to history or society. His depiction of Pope Pius VII of 1805 is one of the most noteworthy examples of this.)[19]

This brief overview of David's drawings, genre painting, and portraits executed in Brussels reveals the richness and complexity of his production in exile at the end of his life. David often claimed that he had never produced greater works in his career. He wrote the following, for example, to his son Eugène on January 1, 1819: "I am very busy with my art, health favors my successes, and if I believe what everyone constantly tells me, I have never created works that are better and more decidedly made in the simple and energetic taste of ancient Greece."[20] David's desire to create such works is manifest in his monumental mythological paintings executed from 1817 to 1824, compositions that share with his other Brussels productions a daring experimentation and often a plurality of styles concomitant with a pronounced interest in psychological intensity and effects. In the last ten years of his life, David concentrated his efforts on these four great works, which would embody his final artistic ideas and constitute, as he declared, his "last farewell to painting."[21]

What one immediately notices about *Amor and Psyche* [FIGURES 2, 27], its pendant *Telemachus and Eucharis* [FIGURES 1, 28], *The Anger of Achilles* [FIGURES 5, 29], and *Mars Disarmed by Venus and the Graces* [FIGURES 6, 30], is that all are concerned with the psychology of love on a multiplicity of levels. It is nothing short of remarkable that David would turn his attention so completely to the theme of love in his Brussels mythological paintings, for only twice in his entire previous career did he deal with mythical love themes in major painted composi-

Figure 26
Jacques-Louis David. *Portrait of Emmanuel-Joseph Sieyès*, 1817. Oil on canvas, 97.8 × 74 cm (38½ × 29⅛ in.). Cambridge, Mass., The Fogg Art Museum, Harvard University Art Museums, Bequest of Grenville L. Winthrop (1943.229).

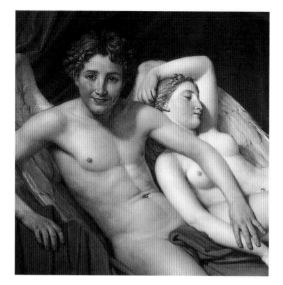

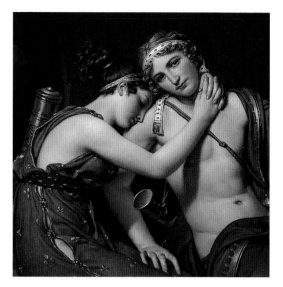

tions—in *The Loves of Paris and Helen*, 1788–89 [FIGURES 3, 31], and in *Sappho, Phaon and Amor*, 1809 [FIGURES 4, 32]. As mentioned earlier, the most disturbing of these works was *Amor and Psyche*,[22] which had been purchased by the Italian count de Sommariva and exhibited by him in Paris.[23] We know from the contemporary press and from letters written to David that viewers were deeply disturbed by the depiction of Amor—instead of the idealized adolescent god of love whom they expected to see, David offered them an awkward, ugly youth, who looks out at the spectator with a leering grin as he makes a clumsy attempt to leave the bed of his beautiful mistress, Psyche.[24]

In his third major work executed in exile, *The Anger of Achilles*, 1819 [FIGURES 5, 29], David interprets a complex nexus of familial love and conflict. Diverging from the literary sources of the myth as recounted in Euripides and Racine, David imagines a moment of the Trojan War in which the great warrior Achilles, the betrothed of Iphigenia, draws his sword on her father, King Agamemnon, who had ordered his daughter to be sacrificed in expiation to the gods so that his fleet might set sail for Troy. Achilles' murderous hand is stayed by the mesmeric command of the king's powerful hand and gaze. The queen, Clytemnestra, recognizes at this moment that her daughter, whom she desperately

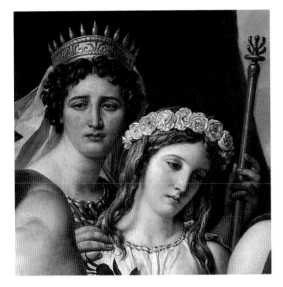

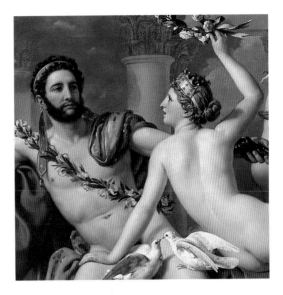

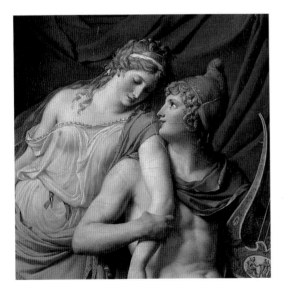

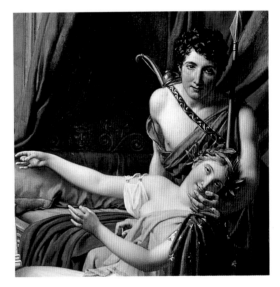

Above:
Figure 29
Jacques-Louis David.
The Anger of Achilles.
Detail of figure 5.

Above:
Figure 30
Jacques-Louis David.
Mars Disarmed by Venus and the Graces. Detail of figure 6.

Below:
Figure 31
Jacques-Louis David.
The Loves of Paris and Helen. Detail of figure 3.

Below:
Figure 32
Jacques-Louis David.
Sappho, Phaon and Amor. Detail of figure 4.

clutches, is doomed. Once again, David uses the device of the family portrait to great effect and compresses the figures uncomfortably into the foreground plane so that we are compelled to view these terrible conflicts close up.[25]

In his final masterpiece, the last work of his career, *Mars Disarmed by Venus and the Graces*, 1824 [FIGURES 6, 30], David sought to express the culmination of his artistic ideas. In a letter dated May 12, 1824, addressed to his dear friends in Paris, Antoine and Angélique Mongez, who were going to set up the exhibition of *Mars and Venus*, he wrote, "Finally, consulting only my love for my art, I thrust myself again into the great career of an even greater historical style. I have decided to paint the gods, a new Titan, I have dared to penetrate their domain; let me not be struck down as they were."[26] I have analyzed this very complex painting in detail elsewhere. Suffice it to say here that David used the mythological theme in this, his final aesthetic manifesto, to interrogate the very nature and history of representation itself at a moment when the entire French school of painting was in crisis, when the struggle between classicism and romanticism had intensified.[27]

The Dream of Adolescent Love

The most appealing of David's mythological paintings executed in Brussels is the eloquent *Farewell of Telemachus and Eucharis* [FIGURES 1, 28]. Somewhat smaller in dimension than the other three mythological paintings executed in exile (87 × 103 cm), the work is also more intimate, sharing with the late drawings, genre painting (*The Fortune Teller*), and *The Anger of Achilles* the format and presentation of a family portrait. As with all his mythological works made in Brussels, David had the painting exhibited for the benefit of the poor (first in Ghent, in May and June of 1818, then in late June and July in Brussels) before giving it to its owner, Count Franz-Erwin von Schoenborn of Munich (a repetition of the painting was made in 1822 by the artist's pupil Sophie Frémiet, under his guidance).[28] An eloquent exchange of letters between David and government officials, in which the painter gives permission for *Telemachus and Eucharis* to remain on exhibit for a longer period of time so that more revenue can be generated for the poor, reveals the artist's deep commitment to charity.[29] David's altruistic acts at the end of his life belie the oft-repeated statements that he, along with his wife, who purportedly served as his financier, was motivated to a considerable extent by greed and financial gain. A great deal of jealousy and resentment had naturally been generated through the course of his career because he was so successful artistically and financially. Beginning with *The Sabine Women* in 1799, he had periodically exhibited his works privately for a small fee; the cumulative effect of this arrangement in terms of monetary reward had often been great.[30]

Unlike its pendant, *Amor and Psyche*, 1817, and the later *Mars Disarmed by Venus and the Graces*, 1824, *Telemachus and Eucharis* was not exhibited in Paris, but the critical responses to it at its exhibitions in Brussels and Ghent were overwhelmingly positive. On July 6, 1818, one of David's Belgian pupils, Joseph Denis Odevaere, published a very enthusiastic review of *Telemachus and Eucharis*, praising it as a work executed by a master, whom age had not debilitated.[31] This positive review, which offers a specific cultural and artistic context in which to view the

painting, was probably written under the influence of David. It is still very useful to us today, for it constitutes one of only two lengthy discussions of the painting written in the nineteenth century (the second, written by N. Cornelissen, will be discussed later in this chapter). Odevaere praised the brilliance as well as the subtlety of color in David's *Telemachus and Eucharis* and acclaimed the mastery, indeed, the perfection in technique, application of paint, compositional format, disposition of the figures, and expression in a work that combines grace and power with facility of execution. The work was created, he claims, like a work of nature— without effort.

We know from conservationist Mark Leonard's recent cleaning and restoration of the painting at the J. Paul Getty Museum that what Odevaere said about the seeming effortlessness was true. Technical analyses of the painting with microscope and infrared photography reveal that David's first strokes of the brush—his outlines of the figures—were, apparently, his final ones; no changes were discovered, and he seems to have worked directly in paint, for no evidence of underdrawing was found on the canvas. (The same methods of direct painting onto the canvas were discovered in *The Fortune Teller*, a work also cleaned and restored by Mark Leonard.) [32] Cleaning and restoration of the painting revealed that David, following his eighteenth-century procedures, first painted Telemachus and Eucharis nude, then painted their costumes. By using this method he was able to determine precision and correctness of corporal forms beneath the clothing, and he was also able to adjust the costumes to a proper "fit." [33] This is testimony to the artist's complete confidence in his creation of forms, his sureness of hand, and his absolute mastery of his art. David had no hesitations; the composition was painted directly onto the canvas as a perfect and harmonious whole. We do not even know of any direct preliminary studies for the composition. A summary sketch and a completed drawing of the entire composition preserved in a private collection were apparently made after the painting was completed. [34]

Odevaere wanted to place David's work in a specific context. He was asserting the artist's position in art history by hailing the work as containing the greatest qualities of antique, Renaissance, and Flemish art (it is interesting to note that no mention is made of French art). But, although Odevaere's review is filled with high praise, he does not offer a specific analysis of the composition, and it may

be helpful here to look more closely at the work in order better to understand what David was trying to achieve, what ideas and emotions he hoped to communicate through his original and compelling interpretation of this theme.

David has done everything in his power to make his presentation of the adolescent lovers gentle and sympathetic. They express a courtly and heartfelt affection for one another as they embrace for the last time. David has imagined the mythical lovers in an intimate moment not found in the literary sources; they have clandestinely met in a dark cave to bid each other adieu. The nymph Eucharis must stay on her island, and Telemachus must leave with his guide, Mentor, in quest of his father, Ulysses, who had not yet returned from the Trojan War. The comely Telemachus, represented in partial heroic nudity, is slender but strong, with clearly defined pectoral muscles, a taut abdomen, and powerful arms. He inclines his head and torso toward Eucharis and partially supports the weight of his body by bracing himself with his right hand placed firmly on her left thigh. His literal inclination toward his lover is expressive of his longing, love, and desire, which are manifest in the very subtle and sad melancholic expression of his face. He has realized that his love for Eucharis will not come to fruition, for he will shortly be called upon to leave Calypso's island. Telemachus looks directly out at us, imploringly as though to appeal to our compassion and understanding. His face, so filled with sorrow and regret, is beautiful and flawless. The figure of Telemachus was based on a live model and, although individualized to a certain degree—he looks like a youth one might expect to encounter in everyday life, as opposed to an idealized, classicized hero existing in a separate realm—his features are nonetheless perfected in form, his skin smooth and translucent, his rosy cheeks and lips akin to those of his lover. The subtle roseate, ivory, green, and blue hues of his skin are also similar to those of the young girl who embraces him. Delicate, golden curls frame his exquisitely rendered face and soften the strongly pronounced structure and the outlines of his temples and jaw. In his left hand he lightly supports his spear, which functions as a counterbalance to the leaning figures, whose configuration is not completely stable. Telemachus's hunting dog looks up toward his face with compassion and devotion. The dog thereby serves to direct our attention to the face of his master, which provides the focal point of the composition; the dog can also be seen as a symbol of the fidelity of the couple's love.

As in all of his Brussels works, David seeks to reveal the complexity of subjective emotional states. Telemachus suffers heartache because he is torn between his love for Eucharis and his duty to find his father and thereby rescue his country, of which his father is king. David reveals Telemachus's status as a royal prince through his costume as well as through his refined corporal and physiognomic characteristics.

Eucharis is presented as an equally beautiful adolescent, whose fully developed, voluptuous figure resembles that of a mature woman. Her ravishing face, however, seen in profile, bent in sorrow against Telemachus's shoulder, is still that of a young girl. Eucharis's gesture and facial expression are just as heartrending as those of Telemachus. She gently embraces him around the neck and her eyes are closed in melancholy contemplation of their imminent separation. She, too, although very beautiful, is clearly based on a live model. Like Telemachus she has individualized features—her ear (one of the most delicate and beautiful ears to be found in the history of painting), nose, and mouth, as well as the shape of her eye attest to this. Thus, she is not based on an antique prototype in art, nor is she presented as an idealized divinity. David privileged the features of the live model for both figures in order to help render them as psychologically compelling as possible. He wanted the viewer to contemplate the melancholy situation of the lovers and to feel compassion for their suffering, which results from their tender love and affection. In order to help achieve this, he placed them in the immediate foreground and made them monumental. They fill almost the entire space of the canvas, and the dark blue-black cave in which they sit serves as a neutral setting to further accentuate their luminous, brilliantly lighted figures. The artist also attended very carefully to minute details; eyes, hair, and skin are rendered with utmost subtlety, refinement, and naturalism. And, as we often find in David, he painted fingers and fingernails in a strikingly precise and detailed fashion. All these elements serve to remove the lovers from the mythological realm and place them in the world of the present. Viewers in 1818, like those today, experienced the uncanny physical and psychological presence and reality of Telemachus and Eucharis.

David has also meticulously represented the hunting attire of the young couple in saturated primary colors of red, blue, and green, highlighted by gold borders and decoration. These brilliant colors, which call to mind the jewel-

like colors seen in medieval manuscript illumination, attest to David's new and pronounced interest in color in his Brussels works. Here he began to use color as he had never done before, not only delighting in the intensity of pure and deep primary colors, but also achieving great feats of subtlety in his depiction of the panoply of blended colors, shadows, light, and translucency in skin tones. The reds and blues of the hunting costumes, in particular, cast colored shadows on the skin of both figures, which is depicted with great technical genius. The artist also represents with great skill the accoutrements of the hunt—Eucharis's quiver and Telemachus's horn. He delights, particularly, in the depiction of reflected and refracted light in his representation of these metallic objects.

David has the lovers lean together and interlock their forms as an emblematic expression of their interconnection, their transcendent love. It is their heads rather than their torsos that are contiguous. David hereby emphasizes that what they feel for each other is a tender affection and friendship rather than an explosive eroticism as described in the literary sources. This helps to explain why Eucharis, although she appears sensual and voluptuous, is fully clothed (although we do see her soft and smooth skin appearing through the clasps and edges of the material of her tunic); erotic attraction is implicit, but it is not the basis of their union. In fact, Eucharis's hunting attire suggests that of Artemis the huntress, goddess of chastity. And Telemachus's semidraped form belongs more to the convention of the heroic nude, emblem of strength, virtue, and truth, rather than to that of the soft and sensual male nudes, objects of sexual desire, that abounded in French art from the 1790s to around 1820.[35] David does not depict Telemachus as a voluptuary. Instead, his body is taut and strong. He is about to resist his love for Eucharis and abandon her.

As mentioned earlier, in his sympathetic and engaging representation of the mythical adolescent lovers, David diverges from the principal literary source as well as from earlier visual precedents. In Books 2 and 3 of *The Odyssey*, Homer describes Telemachus as noble, thoughtful, and godlike. Although he recounts briefly the story of Telemachus's adventures in his quest to find his missing father, he does not introduce Eucharis into his narrative of the trials and tribulations of the youthful Telemachus.[36] The loves of Telemachus and Eucharis were invented by the seventeenth-century abbé and tutor to the dauphin François de Salignac de

La Mothe-Fénelon, who wrote *Les Aventures de Télémaque* (published in 1699) as an adventure story, but also as a significant pedagogical work in order to teach his pupil precepts and codes of right thinking and right behavior, how to act virtuously and resist vice.[37] Fénelon's youthful Telemachus, subject to all types of temptations and challenges, triumphs in each difficult situation, but the most problematic one occurs when he falls in love with Eucharis. This becomes very complex indeed.

In Fénelon's tale, Telemachus and his guide, Mentor (who is really the goddess of wisdom, Athena, in disguise), are shipwrecked on the island of Calypso, the minor deity who had previously fallen in love with Telemachus's father, Ulysses, when he had been shipwrecked on her island. Calypso listens with rapture to the handsome and virile Telemachus as he recounts the exciting adventures of his quest. She falls in love with him, but Cupid arrives on the scene with his dangerous bow and arrows and arranges it so that Telemachus and the nymph Eucharis, one of Calypso's handmaidens, fall in love with each other. In Fénelon's story, it is a passionate love that will never be consummated. Calypso and Mentor are both terribly upset (for different reasons, of course) when they realize what is going on; Calypso is filled with a jealous rage and Mentor with fear that Telemachus's hopeless passion for Eucharis will lead him astray and keep him from continuing his search for his father. Mentor/Athena builds a ship in one day so that Telemachus can be persuaded to leave the island before it is too late. While the ship is being built, Telemachus and Eucharis go out on a hunt together, accompanied by a larger group, and they exchange longing and passionate looks. They want to go off together to be alone, but the jealous Calypso prevents them. Mentor had already tried futilely to persuade Telemachus to give up his love for Eucharis but he realized that erotic passion, inspired by the power of Cupid, is stronger than reason or love of duty. In Fénelon's account, after Telemachus has bid a final farewell to Eucharis, Mentor, doubting the strength of the young man's resolve, pushes him off a cliff into the sea and then swims with him to the waiting ship that will take them away from Calypso's island for good.

The theme of the adventures of Telemachus had been very much in vogue in eighteenth-century French and European art. It was represented numerous times in history painting, and many artists also contributed compositions to the numerous illustrated versions of Fénelon's book, which remained extremely

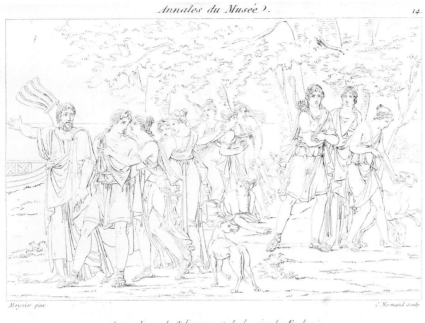

Meynier pinx. *C. Normand sculp.*

Les adieux de Télémaque et de la nimphe Eucharis.

Figure 33
Charles Meynier (French, 1768–1832). *The Farewell of Telemachus and Eucharis,* 1800. Engraving by C. Normand after the painting (whereabouts unknown), published by C.-P. Landon, in *Annales du Musée et de l'Ecole Moderne des Beaux-Arts* (Paris, 1800).

popular and was reprinted many times in new editions. The episode of Telemachus being led away from Eucharis and the other nymphs had gained particular interest during the second half of the eighteenth century, for it provided a perfect example of the theme of virtue, reason, and civic and familial duty triumphing over erotic passion or lust. Several artists painted this particular theme in the early years of the nineteenth century, but none imagined the specific rapport or relationship between the figures as David has done. Typically, the theme was depicted as a public event, not as a private, intimate encounter (the tryst between the lovers imagined by David never took place in Fénelon's account).

In Charles Meynier's large history painting exhibited at the Salon in Paris of 1800, now known only through an engraving published by Charles-Paul Landon in his *Annales du Musée et de l'Ecole Moderne des Beaux-Arts* [FIGURE 33], we observe the traditional way of presenting the theme based on Fénelon's narrative. To the far left the wise Mentor, leading Telemachus firmly by the hand, points to the waiting ship. The young and very handsome Telemachus has stopped in his

tracks and is turning toward the nymph Eucharis, with whom he seems to be pleading. He gazes at her with sorrow, and she returns his melancholy expression as she embraces him, hoping to persuade him to stay. Telemachus is presented as a youth, but in corporal configuration and facial features he appears to be closer to manhood. He is not, certainly, an ungainly adolescent. Eucharis is depicted as a fully mature woman, much older than her beloved. The moment of farewell takes place on the afternoon of the hunt on Calypso's island. Groups of nymphs in hunting attire, carrying bows and quivers, respond in a variety of ways to the departure of Telemachus. To our right, opposite Mentor and Eucharis, we see the angry and jealous Calypso, accompanied by two nymphs and dressed in a short tunic as a type of Diana the Huntress. She carries a quiver and a bow on her back. Her arms are folded, her face is tightened into an expression of anger and consternation; she refuses to look at the departing Telemachus. Meynier emphasizes in his composition the type of female society that prevailed on Calypso's island. The nymphs rule, and they engage in masculine activities such as hunting. In Fénelon's account, as in Meynier's (and later David's) painting, the hunt serves as the ideal metaphor for the type of pursuit associated with erotic passion, in which we typically find the hunter and the hunted, predator and prey. In a reversal of roles, however, in Fénelon's story, Calypso and her nymphs are presented as the aggressors—the hunters—and Telemachus is the prey of these female predators. But Telemachus is a willing prey, and the case can be made for him as a fellow hunter, since he pursues Eucharis, just as she pursues him.

In his composition, David has diverged radically from earlier visual presentations of the farewell scene between the lovers, such as the one we find in Meynier's interpretation of the theme. David removes the lovers from the public realm (where Telemachus's actions as a royal prince expectedly should take place) and situates them instead in a dark cave, in which the adolescents enjoy an intimate moment of farewell, seated, embracing one another. They are dressed in hunting attire, so we know that the moment is the afternoon of the hunt, but here the hunting metaphor takes on a very different meaning. There are no allusions to the idea of pursuit and capture, for the lovers are tenderly intertwined. David imagines that they have achieved what they could not do in Fénelon's account—they have slipped away from Mentor, Calypso, and the nymphs and have taken refuge in a

dark cave, protected from public view. The cave, traditionally a symbolic place of secrecy, magic, and mystery, in the bosom of the earth, hidden from the world, provides an ideal setting for this sorrowful farewell. This transposition from the public sphere (associated with civic duty, virtuous behavior, and public morality) to the private sphere of tender love and erotic passion is of utmost importance for an understanding of the meaning of the work. David wanted to reveal the nature of a mutual exchange of tender affection, of the bonds of true friendship and desire, an intimacy that can only be revealed in private. Love cannot be manifested in the public arena, the spectacle of everyday life in the world—it is a timeless, subjective state of being and feeling. We, as spectators, are made privy to this extremely private moment, which Telemachus, by gazing directly into our eyes, invites us to observe and to contemplate so that we might understand the deep sorrow of the melancholy lovers. It is Telemachus's destiny to leave Eucharis. He will fulfill his duty, which is determined by a fixed narrative, but David compels us to realize the price the hero will pay for duty and civic virtue. Telemachus and Eucharis will both suffer terribly, and David presents us with the sadness, indeed, the tragedy, of their love.

Why did David diverge from *Les Aventures de Télémaque* and invent an episode that Fénelon did not include? Throughout the story of Telemachus and Eucharis, recounted in Book 7 of his tale, Fénelon was trying to teach the dangers of erotic love, this destructive, overwhelming, irrational force that he believed obliterated higher moral objectives. Fénelon wanted to demonstrate Telemachus's weakness in the throes of lust, how the handsome youth would not be able to control himself. This explains why in Fénelon's text the lovers do not meet alone in secrecy. If this had happened, Telemachus might well have given in to his erotic desires, and Mentor's task of removing him from the clutches of this beautiful and dangerous nymph would have been all the more difficult.

But in diverging from the source (something David did very frequently throughout his career—he liked to create moments that would add to the literary narratives and, occasionally, thwart and subvert them), the artist completely and ineluctably transformed the meaning of the story itself. For he does not represent the loves of Telemachus and Eucharis as loathsome or morally reprehensible; on the contrary, he presents the lovers very sympathetically, with great ten-

derness and poignant affection. We feel compassion for these young, star-crossed lovers and wonder at the seeming innocence and purity of their love.

That this was, indeed, David's intention, is revealed in a very lengthy discussion of the painting written by the artist's friend, the classicist and man of letters N. Cornelissen, secretary of the Société royale des beaux-arts et de littérature of Ghent. In 1818 Cornelissen published his lengthy "explanation" of the painting in the *Annales belgiques des sciences, arts et littérature*. This extremely important document was most likely written under the directives of his good friend, David himself, who on several occasions in Brussels intervened in what students, friends, colleagues, and family wrote about his work.[38] In his published account, which was first given as a lecture addressed to members of the society (to which David belonged), Cornelissen examines the literary sources, Homer and Fénelon, both of whom, he claims, inspired David, and he then traces these sources of inspiration, which served as a basis for meaning in the painting, even though David created a new episode of the story. Cornelissen's account offers provocative clues to David's intentions in making this painting, and his observations and interpretations are corroborated by the evidence presented in the painting itself.

Cornelissen establishes a lineage in the recounting of the story of Telemachus: Homer, Fénelon, David. He hails David, who, like his great literary predecessors, is akin to a lyric poet in terms of his embellishment of the narrative:

> Fénelon . . . showed us the Telemachus promised by Homer. Eucharis belongs entirely to Fénelon's brush; but several features also indicate rather the contours of the image that are not fixed on canvas.
>
> David's brush, inspired by the genius of Fénelon and Homer, has brought together these dispersed features, and here is *Eucharis* beside Telemachus for a second time; Eucharis, beautiful with modesty and love! *Telemachus*, son of the divine Ulysses, from whom he has gentleness and pride, with a majestic carriage and demeanor![39]

Cornelissen explains that Fénelon invented Eucharis, this was his great addition to Homer's story in the *Odyssey*, but David takes the brief description of Eucharis and embodies her, gives her new life the second time around, that is, in his paint-

ing. Most striking in Cornelissen's repeated references to Eucharis is his characterization of her beauty—modesty and love make her beautiful. We will shortly return to the signficance of this. For David's representation of Telemachus, Cornelissen constantly quotes directly from Fénelon. Telemachus is continually likened to his kingly and divine father in terms of his handsome figure, the nobility and majesty of his bearing, and his pride combined with gentleness. And Cornelissen also quotes the specific passage in Fénelon that inspired David to represent the farewell of the lovers. It occurs when Telemachus asks Mentor to allow him to bid good-bye to Eucharis: "I have not yet bid farewell to Eucharis." [40] But in spite of pointing out the influence of Fénelon's account, Cornelissen asserts that David transformed the lovers' emotional and psychological situation:

> Because the goal of Fénelon's chaste work was to inspire a rational aversion to sensuality, he did not indicate anywhere that the young lovers for a single moment knew the pleasures of a joyous, tranquil, and satisfying love. *The painter* [meaning Fénelon, who paints a picture with his pen] always offers them to us as suffering and consecrates them to our pity: "*Eucharis burns with a fire more cruel than all the sufferings of death. . . . Telemachus suffers; his pain is intermingled with shame; he weeps bitter tears. His beauty, his enjoyment, his noble pride, flee far from him. He withers like a flower, his bright colors fade and his beautiful head droops.*" Such is the tone of the writer. But this will not be the tone of the painter [David], who must speak to our eyes, to communicate by means of our eyes to our soul the sensations he wishes to stir in us or to make us participate in. He will show us, therefore, his Telemachus, undoubtedly suffering, undoubtedly battling opposing passions, but still adorned with youth and vigor, still divine, still as beautiful as a god. [41]

Cornelissen appositely describes the terrible psychological conflicts that Telemachus experiences in David's composition and emphasizes the complex subjective state of Telemachus, who is filled with longing, sorrow, and conflicting emotions. He points out that David, through use of great subtlety of physiognomy that functions eloquently with posture, carriage, and pose, shows us that Telemachus has still not been able to make the decision to break finally with Eucharis—he remains

irresolute.[42] In his eloquent descriptions of Eucharis, Cornelissen repeatedly refers to her innocence and chastity, as we see in the following excerpt:

> This *Eucharis* who, blushing at herself, has lowered her large eyes
> . . . her features bear the imprint of innocence and chastity . . .
> *David's brush*, as chaste as Fénelon's thought, did not want to
> show us the caresses of sensual delight, but rather those of inno-
> cence. A despairing sister would have tried no differently to retain
> a brother she cherished. . . . The figure of *Eucharis* indicates the
> youth of a virgin.[43]

Cornelissen describes Eucharis as modest, chaste, and virginal in David's painting, but he tells us that Telemachus is equally innocent. An amateur classicist, Cornelissen praises the accuracy of costume of both Telemachus and Eucharis, which, he claims, is antique and Homeric (in all of his Brussels mythological paintings, David was proud of the archaeological "correctness" of many of the details of costume and setting).[44] And he refers to Telemachus's heroic nudity (the nudity, we remember, associated with truth and virtue), in the following terms: "The bust offers this heroic nudity that enhances with such noble decency Homer's warriors and the demigods of Greece."[45] In a very interesting footnote to this line, Cornelissen defends the "decency" of heroic nudity versus the immodesty of naked-ness, referring to specific sources in Homer and Virgil. The point he is trying to make, again, has to do with the modesty and chastity of the figure of Telemachus, which echoes that of Eucharis.

Why was David so interested in representing the lovers as virginal, innocent, modest, and chaste, thereby diverging from Fénelon's account of the cruel passion, brought about by the wicked Amor, that burned in their loins? And why did Cornelissen seize upon this as the greatest contribution David had made in the new episode of the story that he invented in his painting? In order better to understand David's choice of theme and presentation, we need to look briefly at a principal direction in mythological painting of the late eighteenth and early nineteenth centuries in France.

As mentioned earlier, during the second half of the eighteenth century, the academic reforms of the Académie Royale sought to banish licentious and playful mythical love themes in art and to replace them with serious, moral subjects that would teach the public right behavior and noble actions. One important, reformist critic, La Font de Saint-Yenne, declared as early as 1754 that the representation of amatory themes constituted unsuitable subject matter for the philosophical, moral, and didactic objectives of art.[46] These claims, concerned with the degeneracy of erotic mythological representations, resulted in the replacement of popular subjects (such as Boucher's delightful and lighthearted depictions of mythical eroticism and sensuality evinced in provocative works such as *Hercules and Omphale* [FIGURE 17]), with interpretations of the *exemplum virtutis*. The new, didactic movement in history painting reached its zenith in David's acclaimed compositions of the 1780s, such as the *Belisarius* [FIGURE 7], *Andromache Mourning Hector* [FIGURE 8], *The Oath of the Horatii* [FIGURE 9], *The Death of Socrates* [FIGURE 10], and *The Lictors Returning to Brutus the Bodies of His Sons* [FIGURE 11].

During the second half of the eighteenth century, mythological subjects based on the erotic episodes of the loves of the gods and goddesses did not entirely disappear from the French Salons, but the number of such subjects was greatly diminished and replaced by very different kinds of mythical themes. These did not involve specific representations of love and desire but, like the depictions

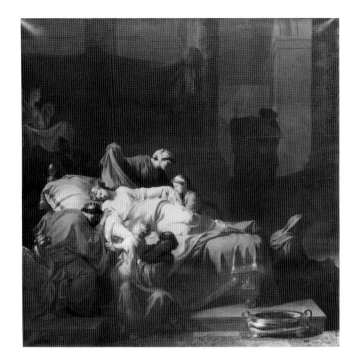

of the *exemplum virtutis* in history painting, they taught virtue and right actions. A good example of this new emphasis on virtue and self-sacrifice in the mythical subject is Pierre Peyron's *Death of Alcestis* [FIGURE 34], in which an honorable queen decides to die in place of her husband. It was exhibited at the Salon of 1785.[47]

It is significant to note that this very period in France witnessed a sudden emergence of extensive writings on myth—new, often annotated editions appeared of classical works, such as Homer, Ovid, and Virgil, many of them illustrated by contemporary artists; and mythological dictionaries, treatises, and pamphlets abounded, frequently characterized by a scholarly, one might almost say scientific, study and explanation of the myths.[48] These studies interrogated the meanings of the myths and offered philosophical and cultural interpretations of the narratives of the loves of the gods and goddesses. Just as the Enlightenment gave birth to so many modern fields of intellectual, scientific, historical, and cultural inquiry, so it also gave birth to the discipline of modern mythography. What had been understood earlier in the century as the playful stories of the loves of the gods

and goddesses, intended to captivate, uplift, and delight their audience, were replaced by serious philosophical interpretations of such themes, which were viewed as metaphors for the human life cycle and the human condition. These kinds of new and widespread interpretations, which permeated the emergent mythological discourse of the late eighteenth century, were directly related to the concurrent pronounced interest in the definition and exploration of the self, one of the great projects of the late Enlightenment that would burgeon into a principal direction in nineteenth-century Romanticism.

It should not surprise us that David, whose peers characterized him as an intellectual, and who thought of himself as a *peintre-philosophe*, would be the first artist to respond to this new, philosophical direction in the reinterpretation of mythical themes. As mentioned earlier, with his *Loves of Paris and Helen* of 1787–89 [FIGURES 3, 31], he proffered a very somber and melancholic interpretation of an amatory mythical subject and thereby diverged strikingly from the representation of stoic themes of civic virtue and heroism that had occupied him throughout the 1780s. In his autobiographical notes written in 1793, David himself claimed that this work constituted an innovative direction in his art (he wrote these notes in the third person to be used in an article by J.-J. Sue):

> In 1787 he made a painting representing the loves of Paris and Helen for the former count d'Artois. He had never before attempted to work in this type of appealing category. He did not do with this appealing category what anyone had ever seen before, he made it in the Greek manner, completely antique. He astonished those who doubted he could succeed in this category of painting, and the praise he received attests to the success of the work.[49]

David was right to express great pride in having created a new type of interpretation of a mythical subject, for his daringly original and innovative *Loves of Paris and Helen*, exhibited at the Salon of 1789, reinstituted the depiction of the excoriated amatory mythological theme and launched a completely new direction in the development of such themes in French painting. Rather than as a Trojan warrior, David depicts Paris as a type of ephebic, exquisitely beautiful Apollo, the lover-poet holding his lyre. In Homer's account in *The Iliad*, Aphrodite had whisked

Paris away from the battlefield, where he had been about to encounter Helen's husband, the Greek king Menelaus, and dropped him off in his lover's bedroom. Paris's love affair with Helen was, of course, the cause of the Trojan War, which resulted ultimately in the downfall and complete destruction of the city of Troy. David has referred to this situation obliquely in the melancholy, downcast glance and sorrowful, inergetic pose of the sensual and beautiful Helen, who wears diaphanous drapery that reveals her breasts and abdomen in an extremely erotic manner. She leans sadly on her lover who gazes up into her face with adoration. Through corporal configuration, pose, and expression David reveals the relationship of the lovers. Paris, who has probably just finished singing a love song, is completely enthralled with the irresistible Helen. She was awarded to him by the goddess of love, Aphrodite, in exchange for his finding Aphrodite the most beautiful in the judgment among the three goddesses Aphrodite, Athena, and Hera. (On the lyre, David has depicted a sculptured relief of the often-represented scene of Paris offering the golden apple to Aphrodite as the winner of the contest.) Unlike Helen, Paris seems untroubled by the potential consequences of their affair. Helen dominates Paris, yet she inclines her head toward him and leans upon his shoulder; the interlocking forms of the figures reveal their mutual love and desire. Much has been written about details in the room's decor, such as the statues and reliefs that refer to earlier moments in the story involving the participation of Eros and Aphrodite in bringing the lovers together.[50]

David's serious and melancholic depiction of erotic love and desire opened up a completely new direction in French painting. In keeping with the concerns of a burgeoning mythological discourse, the artist reflected on the meaning of the love affair of Paris and Helen and created a complex and meditative work that invites the viewer to think about the serious consequences of sexual love. The use of rich yet subdued colors, the absence of sparkling highlights, and the somber lighting of the very cold bedroom setting—most of which is made of marble and stone—contribute to the grave mood and constitute a counterpoint to the warmth and intensity of the passionate lovers.

The appearance of *The Loves of Paris and Helen* at the Salon of 1789 inaugurated a revolution in the representation of the mythical love theme. During the 1790s and the first two decades of the nineteenth century, many of David's stu-

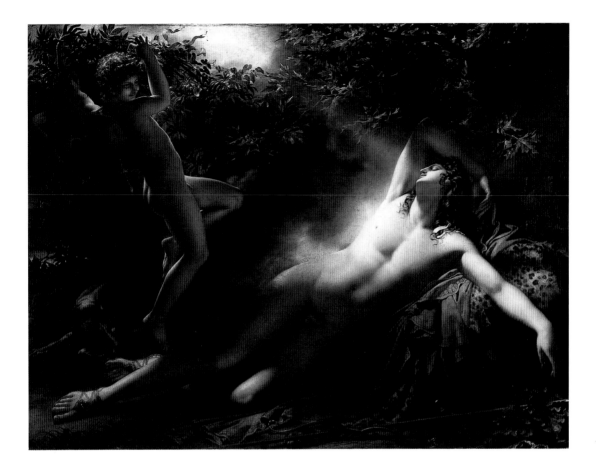

dents and followers concentrated their efforts on innovatory interpretations of the psychology of mythical love. Many were commissioned to illustrate new editions of classical mythological works while at the same time creating major mythical reinterpretations in monumental paintings for the Salons.[51] David's pupil, the brilliant artist Anne-Louis Girodet, became one of the most significant figures in this movement. His lyrical and complex *Sleep of Endymion* [FIGURE 35], which created a sensation at its exhibition at the Salon of 1793, explored subjective states associated with erotic love.[52] Artemis/Selene, goddess of the moon associated with the hunt and with chastity, became hopelessly impassioned with the youthful, handsome shepherd Endymion. Because he would not return her love, she put him to sleep

Figure 35
Anne-Louis Girodet
(French, 1767–1824).
The Sleep of Endymion,
1791–93. Oil on
canvas, 198 × 261 cm
(78 × 102¾ in.). Paris,
Musée du Louvre
(4935). © Photo R.M.N. -
R. G. Ojeda.

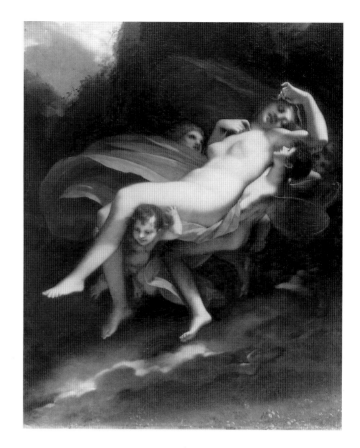

Figure 36
Pierre-Paul Prud'hon
(French, 1758–1823).
Psyche and Zephyr,
1808. Oil on canvas,
64.9 × 48.3 cm
(25½ × 19 in.). Paris,
Musée du Louvre
(RF 512). © Photo
R.M.N.

eternally and visited him at night and made love to him while he slept. Following David, Girodet created a meditational work—he invites the viewer to reflect upon Endymion's strange, terrible yet pleasurable situation. Similar to the narrative of Paris and Helen, the story revolves around a deity becoming involved with a mortal life. Such meddling and interference almost always ends badly for the mortals concerned. In Girodet's painting, Endymion enjoys a pleasurable sleep, yet he is unconscious of this pleasure and will never be conscious again. The extremely voluptuous and sensual youth, lying in a pose associated with a recumbent Venus or nymph (androgynous aspects of the figure have recently been studied in some detail), is visited by his lover in the form of moonlight that caresses his cheek, lips, and torso. A cloying, erotic Zephyr, facilitator of Artemis's passionate love, pulls

back the foliage to allow the moonlight to penetrate the sleeping figure. What Endymion refused to enjoy while conscious and awake, he now completely submits to while asleep when his conscious defenses are broken down—he is helpless and completely vulnerable, yet we cannot say that he is suffering at this moment of sensual delight.

This kind of exploration of the psychological, subjective states associated with erotic passion in the depiction of mythological narratives constituted a principal direction in the reinterpretation of the mythical love theme. Girodet and many others, such as Pierre-Paul Prud'hon, in *Psyche and Zephyr*, 1808 [FIGURE 36], and Pierre-Narcisse Guérin, in *Aurora and Cephalus*, 1810–11, and in *Iris and Morpheus*, 1811, created paintings that critics discussed at length and acclaimed for their psychological complexity as well as their relevance to modern culture.

David himself painted only one other amatory theme while still living in Paris before devoting himself to such subjects in Brussels—his *Sappho, Phaon and Amor*, 1809 [FIGURES 4, 32]. David interprets the psychology of the mythological narrative and, as in *The Loves of Paris and Helen*, he presents a seated and a standing lover in a bedroom (the dramatically foreshortened bed is placed directly behind the couple). In compositional structure, style, and meaning, however, the two works are strikingly divergent. The lyrical beauty of the faces and figures of Paris and Helen, the softness of lighting and exquisite subtlety in the representation of flesh tones are replaced in the later painting by harsh, bright daylight, thickness of contour, and a strange coarseness and uncomeliness in the forms and features of the protagonists, who both have very unpleasant, almost repugnant expressions on their faces. David has ironically echoed his poet Paris in the depiction of his poet Sappho, who is seated and has been singing a lyric dedicated to her beloved, Phaon (his name appears in Greek on the first line of the writing on the parchment in her lap). Sappho seems unaware that the beautiful but malicious Amor has snatched her lyre. The position of her arms and hands reveals that she believes she is still holding the lyre and playing on it, and this strange and empty position in conjunction with her fatuous expression makes her appear foolish, even oafish. She is the antithesis of the graceful Helen of the earlier painting.

The standing Phaon, whose figure seems to parody that of Helen in the 1787–89 work, is not melancholic and reticent, but rather filled with self-confidence

and arrogance. David makes it clear through facial expression and pose that Phaon does not share Sappho's foolish passion. He looks out directly at the viewer with an almost sneering, contemptuous expression as though to assert that he is in control of the situation and is willing to take advantage of Sappho's hopeless, desperate love for him. (According to the legend of Sappho, as recounted by Ovid, Phaon does not return her love and, because of this, she will finally commit suicide by throwing herself off a cliff.) David here uses a pronounced, harsh style and technique to explore in a very different mode a theme that was of interest to him in *The Loves of Paris and Helen*, namely, the psychological effects of passionate love and desire. In *Sappho, Phaon and Amor* we witness the unpleasant situation of an unrequited sexual love, of passion that is not mutual and is, therefore, very disagreeable and disconcerting to observe and to meditate upon.

But what has the tender, gentle, courtly, and sympathetic *Telemachus and Eucharis* to do with representations of such themes as these, which explore the darker, mysterious, melancholic, and, in some cases, sinister or, alternatively, comic, ironic, or parodic aspects of lust and passion? David's *Telemachus and Eucharis* actually belongs to a very different path taken in the development of amatory themes around 1800 in France. Many painters who reinvestigated the meaning of myth were interested in exploring the expression and possibilities of purity and innocence in the development of sexual love, as can be seen in a number of paintings that represent young adolescent lovers in a variety of mythological contexts. This interest in the psychology and, in some cases, the physiology of first love, constitutes a distinct, new, and very popular category in the panoply of subjects chosen by artists who depicted mythical love themes during this period.

The artist who essentially inaugurated this particular direction was David's pupil François Gérard, whose *Psyche and Amor*, 1798 [FIGURE 37], was one of the most written about and highly acclaimed paintings of the Salon of 1798.[53] In the early 1790s, Gérard, through David's direct intervention, had been commissioned to provide a series of illustrations for a new, deluxe edition of La Fontaine's *Les Amours de Psyché et de Cupidon*; it was his work on this commission that led him to create an original and captivating interpretation of the theme of mythical adolescent love.[54] In this painting Gérard presents the god Amor as an idealized, perfected, handsome, ephebic adolescent based on examples of well-known antique

sculpted prototypes. In spite of his role as courtly lover in La Fontaine's tale (which was itself based on Apuleius's late Hellenistic novel), Gérard's Amor is a very chaste looking, hesitant adolescent who barely touches his beloved, whom he is about to kiss. Gérard diverges from the story, in which the god Amor, desperately in love for the first time, abducted the mortal Psyche, rival to Venus in her beauty, and brought her to a magnificent palace, where he lavished upon her every type of comfort, luxury, and entertainment. Psyche was charmed by her lover, but he made himself invisible to her—Amor did not want Psyche to know that she was the mistress of the god of love. Thus, he made love to her nightly, but she never saw him until, one night, driven by curiosity and fear (sentiments encouraged by her jealous sisters: she thought her lover might be a monster), she looked upon him with a lamp and immediately fell in love. The recognition scene with Psyche and her lamp was the most popular episode of the story in painted versions from the Renaissance onward. In the next moment of the story, which was rarely represented until the last decade of the eighteenth century when it suddenly became current, Amor awakened and, infuriated with Psyche for having disobeyed him, immediately abandoned her. The remainder of the story in both Apuleius and La Fontaine has to do with Psyche's quest to find Amor and recover his love (a quest in which she ultimately succeeds after many misadventures, trials, and tribulations).

Gérard, following the example of his teacher David, chose to invent an episode not found in either of the literary sources. He presents the lovers on a mountainside on a sparkling spring morning (the landscape, lighting, and atmosphere are as magnificently represented as the figures). The season and time of day serve as metaphors for the new, budding love of the adolescents. Psyche cannot see her approaching hesitant lover, but she feels his presence. Amor's chaste, boyish form and modest reticence suggest that he has not yet had intercourse with his beloved, who is depicted as an innocent, modest, virginal young girl. She sits with her knees locked together and, although her drapery has slipped from her shoulders, she chastely crosses her arms beneath her breasts. She stares outward but does not look directly at the viewer. Instead she seems to be reflecting, looking inward as she experiences the awakening sensations of love and desire that Amor kindles in her. This was precisely the way in which critics of the time described Gérard's interpretation of the mythical lovers, and they continuously praised the

artist for his ability to represent the psychology of emergent adolescent love in all of its sensual innocence. Innocence and purity are the terms contemporaneous observers used to describe the figures in the painting. One astute critic, writing for the *Décade philosophique, littéraire et politique*, described Psyche's state of sensual innocence in the following terms:

> Do not approach, you whose arid and colorless soul ignores the all-powerful and celestial charm attached to lovable modesty, to shy and religious respect, to all of this ineffable mixture of desires and restraint of which true and pure sensual delight is made! This beautiful body is veiled in decency. . . . This is a simple, candid, virtuous, ingenuous young girl; but where is the sensuality? Don't you see it in her innocence? [55]

Another observer used similar language in his analysis of Gérard's Psyche describing her modesty, innocence, and virginal heart. [56] What was the great appeal to the public of 1798 in Psyche's grace, modesty, innocence, her virginal heart, her shy and religious respect, her restraint combined with ineffable desires that together constituted true and pure sensual delight? Louis-Sébastien Mercier, a perceptive observer of the mores of his day, analyzed the precise psychology of the moment Gérard represented in an attempt to explain why huge crowds flocked to this painting: "If I am not mistaken, it is the instant of transition from adolescence to youth that the painter has wanted to reveal to us." [57] Mercier described in some detail how Gérard represented a liminal moment of transformation when a young, innocent, virginal girl experiences the psychological and physiological changes brought about by the approach of her first lover. This experience serves as a catalyst in her development from a child into a woman and thus represents an extremely significant moment in the human life cycle. Everything in the painting serves to indicate that Gérard intended to emphasize this meaningful moment in human development. The traditional metaphorical use of the landscape setting confirms this: a sublime mountain peak at dawn on a springtime morning emblematizes a specific stage in the cycle of life.

The great success of Gérard's painting resulted in a long series of works that represented adolescent mythical couples who, like Gérard's Psyche and

DAPHNIS ET CHLOÉ.

Amor, were innocent voluptuaries on the verge of experiencing and recognizing their emergent sexuality. Longus's late Hellenistic pastoral tale of the devoted childhood friends Daphnis and Chloe, who fall in love as adolescents, was one of the most frequently depicted narratives describing the chaste yet sensual innocence of two youths. Painted interpretations of the theme abound in the early nineteenth century, such as Joseph Franque's intense, pastoral lovers exhibited at the Salon of 1808 [FIGURE 38], but one of the most splendid and beautiful was Louis Hersent's version of 1817 [FIGURE 39], completed one year before David's *Telemachus and Eucharis*. Hersent has imagined a moment of innocent awakening sexuality when the young couple, who had been playing in the woods, have sat down on a luxuriously wooded spot in front of a grotto. Daphnis is pulling a thorn from Chloe's foot. Although completely nude and pressing against one another (Daphnis has his arm around Chloe), the beautiful young adolescents do not yet seem aware of their own sexuality and their desire for one another which, according to Longus's story, was gradually awakening. It is not surprising that critics of the

time praised the painting in the same terms and for the same reasons as they had Gérard's painting nineteen years earlier. The critic for the *Journal de Paris* wrote: "Such is the innocent simplicity of these two figures that their nudity, at first glance, does not in any way contradict modesty."[58] And the archaeologist and theorist Toussaint-Bernard Emeric-David acclaimed Hersent's interpretation in the following terms: "They are nude and breathe innocence. Their soul is painted in their bearing and on their faces. The group is as well composed for picturesque effect as it is ingeniously conceived to express the reciprocal affection of two young lovers."[59] What is so striking about the terms used to describe both Gérard's *Psyche and Amor* in 1798 and Hersent's *Daphnis and Chloe* in 1817 is that these are the very same terms Cornelissen used in 1818 to characterize David's *Telemachus and Eucharis*. We remember that Cornelissen described the features of Eucharis as expressive of innocence and chastity, that her sensual caresses offered innocence, that her figure was virginal, that Telemachus sighed with unfulfilled desire, that his nudity was heroic and decent, and that David's painting was as chaste as Fénelon's narrative although it depicted a moment of private intimacy between the lovers.

In his representation of *Telemachus and Eucharis*, David was offering his original contribution to this distinct category of mythical representation: the chaste, innocent, virginal, yet sensual adolescent lovers. The painting constitutes the only example in his entire oeuvre in which he represented such a theme, and it is particularly unusual in that he chose the theme in Brussels, for his other paintings as well as his drawings executed in exile explore almost exclusively the darker side of sexuality, often expressed in either sinister or parodic terms. David, in fact, as mentioned earlier, painted *Telemachus and Eucharis* as an antidote to his brilliant but thematically and stylistically repellent and rebarbative *Amor and Psyche*, his first Brussels painting, completed in 1817 [FIGURE 2]. In a letter to Van Brée of October 20, 1817, David called *Telemachus and Eucharis* a "pendant to my Psyche," thereby revealing that the two compositions were conceptually interconnected (they were made for different patrons, however, and David did not expect them to be exhibited side by side).[60]

In the *Amor and Psyche*, as we have seen, David depicted the god of love as a repulsive, clumsy, leering adolescent who gloats triumphantly over his sexual conquest; his beautiful, graceful, and sensually innocent lover is unaware of

Amor's true, monstrous nature. But David makes us, the viewers, only too aware of the ugliness and awkwardness of the adolescent god of love, whose features and forms are expressive of his repulsive character. He leers at us with a satiated grin as if believing us to be proud of his conquest, as if to show that he knows we approve of his behavior. Through his direct engagement with the spectator, Amor seeks to make us accomplices and solicits our approval of his repulsive adolescent bravado. In this painting, David shows us how physically and morally repugnant adolescent sexuality and, by extension, the nature of sexual rapport between men and women can be, absent love, respect, or even tender affection. Amor does not love Psyche, he uses her as a pawn in his game of sexual conquest; he has power over her and has literally and figuratively enslaved her. This rapport is very disconcerting to witness. Many critics of the time had denounced the painting for depicting such a terrible spectacle, and one percipient observer, the art theorist Auguste Hilarion Kératry, even described it as "heartrending" and denounced this "conquest of an ignoble nature over idealism; it makes one sad, it wrings the heart."[61] Kératry would also reprimand David for having created such a "miserable parody" of the theme of young love:

> There is no god here; there never was one. There is no woman who would not be frightened by the sight of the being who has usurped his place.
>
> In this scene, where a crass nature triumphs and toys with the most gentle emotions granted in life, the heart constricts; it feels oppressed by an overwhelming weight. Thought turns in on itself, wonders, and asks with bitterness if the happiness promised here below, in which tender goodness is sometimes interspersed with our sorrows, is no more than the miserable parody offered by the brush of M. David.[62]

We recall that David's *Amor and Psyche* had been privately exhibited in Paris, where it was so psychologically disturbing that it was disliked by almost everyone who saw it. Even David's most devoted students, such as Gros, were puzzled. Gros wrote to David that "the head of Amor has a somewhat faunlike character, the hands are somewhat dark and above all not refined enough"; and David's friend,

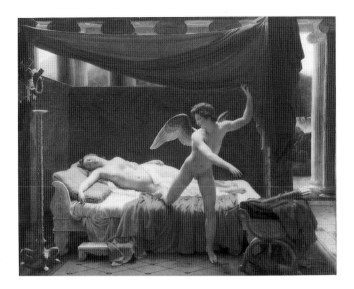

the critic Edmé François Antoine Marie Miel, wrote, "This Amor is not a god, he is not even a beautiful adolescent; he is the model, an ordinary model, copied with a servile exactitude, and in whom the expression of happiness is nothing more than a cynical grimace." [63] David believed that he would be vindicated in the future, that posterity would be able to understand and properly judge the meaning of his *Amor and Psyche*. In the anonymous *Notice sur la vie et les ouvrages de M. J.-L. David*, written in 1824 under the directives of the artist himself, we read: "M. David has not yet concurred with the criticism made concerning Amor . . . he invokes the judgment of the future in order to assess the position that this work should hold." [64] The painting was so ahead of its time, in fact, so modern in its analysis of the psychology of adolescent sexuality, that not until the late twentieth century has it been appreciated in all its complexity and subtlety of meaning.

The public of David's day could not fathom the meaning of such a shocking composition. In 1819, two years after David's *Amor and Psyche* had been shown in Paris, crowds flocked to see François Picot's interpretation of the same moment in the theme [FIGURE 40]. Picot gave the public what it wanted to see in terms of the representation of the narrative moment. His Amor is the antithesis of David's monster. Depicted completely nude, Amor is a slender, idealized, and

chaste-looking young boy, whose genitals appear barely developed. As he departs at dawn, he looks back longingly at his voluptuous mistress, Psyche, who appears as a type of mature, older woman, who could easily seduce and take advantage of an innocent youth. The bedroom is palatial, lavishly decorated and airy, placed in a magnificent landscape setting with a rushing waterfall, the opposite of David's cramped, claustrophobic room and narrow, constricted bed. David intended everything in his composition to emphasize the theme of sexual oppression but his public was not ready to see such disturbing psychological truths expressed through the mythical mode. Perhaps David himself felt he had been too severe, too cynical in his interpretation of the theme that constitutes a parody of adolescent love. He realized, of course, that sexuality and young love were not always based on conquest, oppression, and power. Thus, he painted *Telemachus and Eucharis* to show that another kind of adolescent love was possible. He used the mode of sensual innocence and virginal purity of the adolescent mythical lovers that had been popularized by his student Gérard in 1798 (in the latter's *Psyche and Amor*, FIGURE 37) and had remained popular as a principal amatory mythological subject throughout the first decades of the nineteenth century.

The harmonious forms of Telemachus and Eucharis; the tender, heartfelt love, affection, and sorrow that they share for one another; and the absence of a predatory male or female sexuality taken together stand in dramatic contradistinction to the compositions David habitually produced in Brussels. We remember that even in his drawings representing mythical couples (although usually not specifically identified), David revealed the psychological problematics of sexual rapport. In an undated late psychological drawing executed in a format, composition, and style akin to others looked at earlier and sometimes called *Dido and Aeneas*, or *Phaedra and Hippolytus* [FIGURE 41], David represented in the immediate foreground an adolescent warrior, whose facial features strongly resemble those of his Telemachus. The warrior is listening with considerable reserve to the intense pleadings of a heavyset, older woman, a middle-aged queen, who indelicately embraces him; she hunches over so that she can place herself in a position of subservience. We can only guess at the proposition she is offering—a very slight smile plays around the lips of the youth.

In another Brussels drawing, which has sometimes mistakenly been called *Orpheus and Eurydice* [FIGURE 42], we see a young couple who closely resemble the models of Telemachus and Eucharis. As is typical in his late drawings, David does not make it clear who the figures are, but the references to antiquity in costume and accoutrements are clear. The young girl who embraces the youth around the neck and chin as she leans her head sadly on his shoulder, echoes the figure of Eucharis. The handsome adolescent boy holding the lyre looks out at us like Telemachus, but his face expresses a very different complex of emotions.

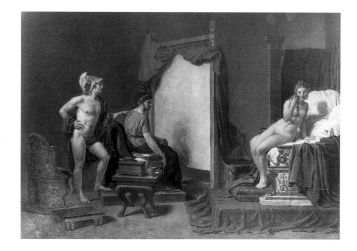

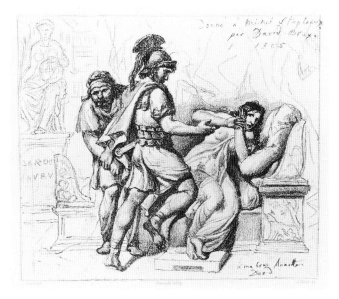

He appears empty, bored, and tired; he completely lacks the soulful melancholy and tender affection that we see in Telemachus's expression. Dido and Aeneas as well as the so-called Orpheus and Eurydice are unhappy couples, indeed, and David shows that, psychologically, unrequited love can be an extremely unpleasant and disturbing situation to observe.

Other compositions that David worked on in Brussels reveal that his interest in exploring the darker and more complex aspects of love and sexuality was not limited to mythological themes alone. In *Apelles Painting Campaspe before Alexander* [FIGURE 43], begun in Paris and completed in Brussels in 1817, David represented the theme of the interrelationship of artist, model, and patron.[65] In the famous narrative, which is recounted by Pliny, Alexander the Great commissioned the fourth-century-B.C. painter Apelles to do a portrait of the former's mistress Campaspe. Apelles fell in love with his model and, as a token of esteem, Alexander gave Campaspe to the painter. David, unlike preceding artists who had treated the theme, transformed the straightforward narrative into an expression of uneasy, disturbing interrelationships inspissated with sexual tension. Apelles, slumped dejectedly before his huge canvas, is seemingly overcome by the sight of the captivatingly beautiful model, while behind him, the patron, Alexander, looks on. The unmade and very rumpled bed along with the complete nudity of Campaspe and almost complete nudity of Alexander, suggest that the king and his mistress have just recently made love. Campaspe withdraws hesitantly from the intense gazes of her two male admirers. She leans away from the artist and the king, and through the twisting of her torso and position of her right arm and hand, she appears to be trying modestly to obscure their view of her breasts. Campaspe appears very unhappy indeed. David presents her as a less-than-enthusiastic participant in the sitting; she certainly does not relish her role as object of erotic admiration. The scene is sexually intense and psychologically disturbing, for we are led to reflect on the uneasy relationship of these three figures (presumably Alexander has not yet given away Campaspe as a gift to Apelles).

In one of the last known compositions of his career, a highly detailed drawing of the *Rape of Lucretia* [FIGURE 44], known from an engraving by Jules David, David interprets a narrative from Roman history that has to do with a terrible rape. He distinctly emphasizes the physical and psychological brutality of the story. Lucretia withdraws in terror from her savior because she has just been victimized and terrified by a brutal man. The composition is extraordinary in its attempt at psychological realism. David sympathizes with the hapless young woman who has been sexual prey to a brutish, apelike man, a vicious and heartless criminal. David, surprisingly, dedicated the drawing to his daughter-in-law Annette,

Figure 45
Jacques-Louis David.
*Telemachus and
Eucharis*, 1818. Black
ink. Paris, Ecole natio-
nale supérieure des
Beaux-Arts, ms. 316,
no. 28.

his son Eugène's wife (he has written below the figures "a ma bru Annette,"
although above he records that the drawing was given in 1825 to Michel Stapleaux,
one of his students). That David dedicated the drawing of such a brutal subject to
his daughter-in-law suggests that the choice of subject had something to do with
the artist's private family life. And, in fact, David may have been directly inspired
to explore themes of disturbing psychological realities of sexual rapport in his
Brussels works because he could observe such themes in his own family. His beloved
daughter Pauline was abused by her husband, and David, along with Pauline's
mother and siblings, was acutely aware of her suffering. Pauline and her young
daughter Emilie often stayed with her parents in Brussels. She separated from her
husband in 1824.[66]

By contrast, *Telemachus and Eucharis* explores the positive aspects of
love and friendship. On a drawing of the motif preserved at the Ecole nationale
supérieure des Beaux-Arts [FIGURE 45], David copied a favorable review of the
painting that had appeared in the *Journal de Commerce* on July 16, 1818. In the last
line of the article the critic commented that only one thing was missing from the

painting—a Raphael and a Rubens to admire it, thereby offering David the high-
est form of praise by placing him in the company of great past masters. In this
drawing David offers a very different presentation of the lovers, an alternative
version of the theme that is highly erotic and serves, by contrast, to show how
modest, innocent, chaste, and restrained the couple in his painting are. A nude and
full-breasted Eucharis sits on the lap of Telemachus and sadly leans her cheek
against his head. He looks intensely into her face as he clasps her firmly around the
waist. The lovers are completely involved with each other, neither gazes out at the
spectator. In his painting, as we have seen, David made the lovers sit slightly apart,
their torsos are not contiguous, and he emphasized the lack of intensity in their
gestures. Eucharis very lightly and gingerly embraces Telemachus around the
neck, and he gently places his hand on her thigh to support her leaning figure. In
the painting the young adolescents are timid, not overwrought by passion, not
erotically intense as they are in David's drawing of the theme.

 Telemachus and Eucharis provides compelling evidence of David's pro-
found meditation on the psychology of love during the last years of his life. His
contribution to the popular theme of innocent and virginal adolescent lovers, in
accord with depictions of Daphnis and Chloe and Gérard's *Psyche and Amor*, reveal
that he understood the psychology of sexual desire and love as highly complex and
multifaceted. And, although he demonstrates in *The Loves of Paris and Helen*, in
Sappho, *Phaon and Amor*, in *The Anger of Achilles*, and in other works, the destruc-
tiveness of the erotic force, in *Telemachus and Eucharis* he offers the antidote to
what otherwise would have been an unrelentingly negative interpretation of the
mythical (and, by analogy, the modern) psychology of love. In *Telemachus and
Eucharis* David asserts that purity and innocence in love can exist. In this painting
he fulfills the early nineteenth-century dream of adolescent love.

THE FUTURE OF MYTH

In 1819 David's former pupil Etienne Delécluze, who had transformed himself from a painter and disciple of David's into an art critic and a man of letters, wrote at length on the meaning of myth and why mythological subjects in art are the best vehicles for expressing the workings of the human heart.[67] Delécluze declared that the Greeks understood the heart better than anyone else in history, and that they revealed in their myths the truths of the human condition. He explained that, unlike amatory themes from "modern" history, such as Paolo and Francesca (from Dante's *Inferno*) and Abélard and Héloïse, which are filled with barbarous and jealous characters who make the hapless lovers pay a terrible price, the Greek mythical love stories are simple, pure, and free from the trappings of civilization. They are "primitive" in their innocence and incorruptibility:

> Today I want someone to paint for me love disengaged from all the complications of civilized life. . . . I want to be given the idea of love as one imagines it when one is only sixteen years old, without suffering, without complications. I admit that it is on these occasions that it seems to me that only mythology can communicate with my imagination and is privileged to awaken in me fugitive sensations like the age that has given birth to them.[68]

For Delécluze, mythology expresses a pure and therefore highly commendable precivilized state of mind, emotion, and imagination. Myth can serve to recapture the psychology and emotions of the early stages of the human life cycle, those of childhood and adolescence; it can reveal the purity of emotions associated with adolescent love. We can see how this analysis of the function of amatory mythical themes accords well with David's representation of "sensually innocent" young love in *Telemachus and Eucharis*.

In his lengthy discussion of myth, Delécluze asserted the importance of mythological subjects in art. He claimed, indeed, that such subjects were indis-

pensable, for Christian narratives were too restrained in range of style and meaning (which is always christological). Furthermore, historical themes were always filled, of necessity, with references to the sordid details of so-called civilized life. Humankind was the center of meaning in the Greek myths because pagan divinities were based on the models of actions and emotions of real men and women. Myth, Delécluze concluded, was the best means for the visual artist to explore the human condition.[69]

In his Brussels works, David fulfilled these prescriptions for mythical meaning. By focusing on the mythical theme in his monumental history paintings at the end of his career, David was asserting that such themes provided the richest and most subtle vehicles for the representation of human nature and psychology, which, he believed, should be the principal expressive interest of painting. Because the mythical subject in art is removed from the necessary constraints imposed on the depiction of historical narratives, whether ancient, medieval, modern, or contemporary, it can express a more generalized, universal meaning. Myth will always be relevant to modern culture because it teaches us most about ourselves, about our motivations and behavior, about how we feel, and how we treat one another. (More recently, Joseph Campbell's very popular writings on world mythologies have taught the same lessons.) David believed, as did Delécluze, that in the myths, we find human nature and behavior distilled to its pure essence. In his Brussels paintings, David used the mythical theme to explore the mystery and power of the human psyche. By exhibiting many of these compositions in Brussels and Paris, he hoped to continue to inspire his students and followers to effect a true renascence of myth, one in which mythological themes would be interpreted as a means of exploring human psychology.

By promoting the representation of mythical subjects in this way, David, still a very influential figure in exile, opposed what were soon to become the leading new directions in nineteenth-century art. In 1819, Théodore Géricault, a great admirer and emulator of David, exhibited at the Paris Salon *The Raft of the Medusa* [FIGURE 46], a work that, although somewhat conventional in composition, execution, and style, was highly unconventional in its choice and interpretation of subject. Géricault chose to depict on a monumental scale a catastrophic and deplorable event from contemporary French history in which the government was

Figure 46
Théodore Géricault
(French, 1791–1824).
The Raft of the Medusa,
1819. Oil on canvas,
491 × 716 cm
(193⅜ × 281⅞ in.).
Paris, Musée du Louvre
(4884). © Photo R.M.N. -
Arnaudet.

strongly implicated. This painting, which emphasized death and destruction as it explored the extreme psychological states of the bereft survivors of a shipwreck, would give impetus to new directions in French art in works based on contemporary history that explored the cruelty and horrors to which human beings subject one another. Eugène Delacroix's *Massacre of Chios*, 1824 [FIGURE 47], a depiction of a horrific episode from the Greek War of Independence in which Turks slew unarmed men, women, and children, immediately comes to mind. This is just the type of "sordid" theme from modern history that Delécluze was protesting against in his apology for the choice of mythological themes in art. And it is not adventitious that many of David's most celebrated students of the early nineteenth century who became famous artists themselves devoted some of the greatest paintings of their careers to poignant reinterpretations of mythical themes.

Girodet, to a greater extent, perhaps, than any of David's other students, had been profoundly involved with the reinterpretation of myth since the beginning of his career. He announced this direction in his art with a student work

Figure 47
Eugène Delacroix
(French, 1798–1863).
The Massacre of Chios,
1824. Oil on canvas.
Paris, Musée du Louvre
(3823). © Photo R.M.N.

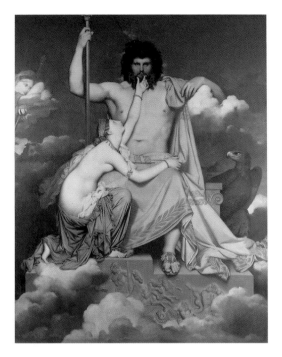

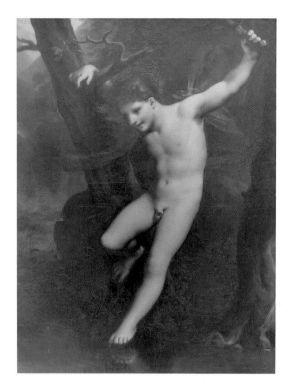

Figure 48
Jean-Auguste-Dominique
Ingres (French, 1780–
1867). *Jupiter and
Thetis*, 1811. Oil on
canvas, 327 × 260 cm
(128¾ × 102⅜ in.).
Aix-en-Provence, Palais
de Malte, Musée
Granet (835-1-1). Photo
by Bernard Terlay, Aix.

Figure 49
Pierre-Paul Prud'hon.
*Young Zephyr Balancing
above the Water*, 1814.
Oil on canvas, 327.7 ×
248.3 cm (129 ×
97¾ in.). Paris, Musée
du Louvre (RF 2695).
© Photo R.M.N.

done in Rome, *The Sleep of Endymion*, 1791–93 [FIGURE 35], a painting that cata-
pulted him to fame. In the 1790s, like Gérard, Girodet worked on illustrations of
newly re-edited classical authors, and throughout the Empire he created hundreds
of drawings based on mythological themes. During the second decade of the nine-
teenth century, other pupils and emulators of David created complex mythical
compositions. Ingres's strange and rebarbative *Jupiter and Thetis*, 1811 [FIGURE 48];
Prud'hon's lyrical *Psyche and Zephyr*, 1808 [FIGURE 36], and his enigmatic *Young
Zephyr Balancing above the Water*, 1814 [FIGURE 49]; and Hersent's *Daphnis and
Chloe*, 1817 [FIGURE 39], proffer but a few examples of numerous works executed in

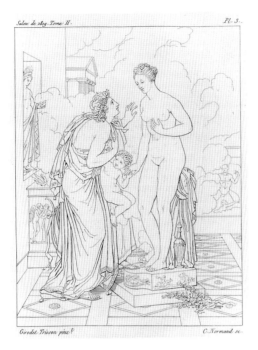

Girodet Trioson pinx.ᵗ C. Normand sc.

Figure 50
Anne-Louis Girodet.
Pygmalion and Galatea,
1819. Engraving by
C. Normand after the
original oil painting, now
in the collection of the
duc de Luynes, Château
de Dampierre. Published
by C.-P. Landon, in
*Annales du Musée et de
l'Ecole Moderne des
Beaux-Arts* (Paris, 1819).

this popular category of painting. (It should be noted that mythological themes also abounded in sculpture during the same period.)

One of the most beloved mythological paintings of the period of David's exile, one that had a stunning success at the Salon, was Girodet's *Pygmalion and Galatea,* 1819 [FIGURE 50].[70] Art critics, archaeologists, theorists, and amateurs described this painting in exalted terms for its physiological and psychological realism. The work so captivated the public that it far overshadowed Géricault's *Raft of the Medusa,* which was shown at the same Salon and received far fewer, more modest, and reserved reviews. The Pygmalion narrative, taken from Ovid, had been a popular theme in art since the eighteenth century. The sculptor Pygmalion fashioned a beautiful female figure and fell in love with it; thanks to the intervention of Venus, the statue came to life and was united with her creator / lover. Girodet depicted the very moment when Galatea comes to life and the agency of Amor that brings about this transformative miracle. Pygmalion is humbled before the beautiful woman he has created. In eighteenth-century painting and sculpture,

the myth had been interpreted according to one obvious metaphorical meaning, namely artistic creation and the relationship between the artist and the beautiful human form he is capable of creating. The critics believed that Girodet's reinterpretation, which emphasizes the role of erotic energy in artistic creation, also embodied truths about human nature, emotion, and behavior. In other words, they aptly perceived that Girodet's painting was about the psychology of love.

David knew, of course, of Girodet's painting and the great success it had achieved, and he worked hard to continue to promote the creation of mythological compositions. Not only did he paint and exhibit his own mythical reinterpretations but he also encouraged his former students in Paris and current students in Brussels to produce such subjects. In particular, he urged them to choose mythological episodes that would provide the best vehicles for the expression of complex psychological and emotional situations, compositions that would be pertinent and relevant to contemporaneous cultural values and concerns, yet would express what were then believed to be universally valid truths.

One of David's most successful Belgian pupils, François-Joseph Navez, who had come to Paris to study with David in 1813 and returned to Brussels with his exiled mentor in 1816, was known principally for his religious paintings and his portraits. Inspired by David, however, he attempted several times to reinterpret mythical themes.[71] One such original and striking reinterpretation is his representation *The Nymph Salamacis and Hermaphrodite*, 1829 [FIGURE 51]. Following the directions proffered by David in his late mythological compositions, Navez presented a highly erotically charged yet sexually and psychologically troubled image of the beautiful young couple. The nymph Salamacis had fallen in love with Hermaphrodite; she had spied him bathing and aggressively pursued him, although he resisted her advances. Navez imagined a moment from the myth when Hermaphrodite had been caught by Salamacis; she half kneels and places herself in a submissive position of sexual offering as she embraces her beloved and seems to be pleading with him to love her. Hermaphrodite looks down at her with consternation, but he leans toward her cheek, as if he may, perhaps, be about to succumb to her charms. This episode depicts a liminal moment of irresistible desire that precedes the dramatic transformation. In the Ovidian account, Salamacis asks the gods to conjoin her physically with Hermaphrodite so that they can never be sepa-

Figure 52
Angélique Mongez
(French, 1775–1855).
Orpheus in Hades, 1808.
Engraving by C. Normand
after a lost painting, pub-
lished by C.-P. Landon,
in *Annales du Musée et
de l'Ecole Moderne des
Beaux-Arts* (Paris, 1808).

rated. Her prayers are answered, and the two become sexually united into one being that has both female and male sexual characteristics. Navez has convincingly represented a troubled eroticism in his exploration of the mythical psychology of sexuality.

From the late eighteenth century onward, David had promoted his women students, most of whom have been unjustly neglected by historians of art. Several of these painters were actively engaged in creating monumental mythological paintings, which belies the prevailing concept that women artists in early nineteenth-century France were limited to representing the "lesser" categories of genre and still life. One of David's most brilliant pupils in the early nineteenth century, for example, was Angélique Mongez. We know from his correspondence that David valued her highly both as an artist and as an intellectual. In Brussels he eagerly awaited her assessments of his mythological paintings.[72] Mongez frequently exhibited complex, monumental mythological compositions at the Salons in Paris, and her works met with enthusiastic critical response. In 1808 she exhibited *Orpheus in Hades* [FIGURE 52], a large composition published by Landon in his *Annales du Musée et de l'Ecole Moderne des Beaux-Arts*—he praised this intricate and very complex painting in the highest possible terms.[73]

In Brussels, David discovered another highly talented woman artist, who became his student. Sophie Frémiet was the daughter of a French liberal who had gone into exile in Brussels when the monarchy returned to France. In Brussels she met and married another of David's pupils, the Romantic sculptor François Rude. Inspired by David's privileging of myth, Frémiet painted and exhibited several very important mythological compositions during the 1820s. She also collaborated with David on several repetitions of his Brussels paintings, including, we remember, one of *Telemachus and Eucharis* in 1822.[74] Her depiction of the mythical theme *The Beautiful Anthia*, exhibited in Ghent in 1820, was recognized as a painting of great merit.[75] But Frémiet's *Ariadne Abandoned on the Island of Naxos* [FIGURE 53], exhibited in Ghent at the Salon of 1826, reveals to a much greater degree than the earlier works the extent to which she had absorbed the lessons of mythical psychology learned from David. She represents the seated, melancholy figure of Ariadne, who has been abandoned by her lover, Theseus, on the island of Naxos. Her beautiful face expresses the depth of her suffering, longing, and resignation. She looks out to sea and extends her arm, perhaps in a final farewell to Theseus's ship as it disappears on the horizon. Seated in a lyrical landscape by the sea, she still broods over her love for Theseus, who so cruelly abandoned her. The delicate and graceful figure of Cupid, with the inverted torch of love, was described in the Ghent exhibition catalogue of 1826 in the following terms:

> Her spirit, who, according to Platonic psychology, is the absolute arbiter of her behavior, the assiduous witness of her actions, the confidant of her most secret thoughts, is here represented as the symbol of her misfortune and he turns upside down the torch of an unhappy love without extinguishing it.[76]

Frémiet's choice of the significant moment from the narrative differs radically from the episode painted in 1820 by David's former pupil Gros, *Bacchus and Ariadne* [FIGURE 54]. Gros's painting is of special interest because he executed it for the German count von Schoenborn as a pendant to David's *Telemachus and Eucharis*. David had engineered the commission for his former star pupil, to whom he had entrusted his atelier in Paris when he left for Brussels. David and Gros

Figure 53
Sophie Frémiet (French,
1791–1867). *Ariadne
Abandoned on the Island
of Naxos*, 1826. Oil on
canvas, 170 × 225 cm
(66⅞ × 88⅝ in.). Dijon,
Musée des Beaux-Arts
de Dijon (4869).
© Musée des Beaux-
Arts de Dijon.

Figure 54
Baron Antoine-Jean Gros
(French, 1771–1835).
Bacchus and Ariadne,
1820. Oil on canvas,
89.7 × 105.1 cm (35 ¼
× 41 ⅜ in.). Phoenix,
Arizona, Phoenix Art
Museum, Museum pur-
chase with funds pro-
vided by an anonymous
donor (65.60). Photo by
Craig Smith.

Figure 55
Baron Antoine-Jean Gros.
Sappho at Leucadia,
1801. Oil on canvas,
256 × 213.3 cm
(100¾ × 84 in.).
Bayeux, Musée Baron-
Gérard (23P).

remained very close, and their warm and intense letters provide great insight into their friendship and into David's role as mentor and teacher.[77] David had consistently urged Gros to produce a "true" history painting, one based on ancient history or myth, rather than the depiction of contemporary historical events, for which Gros had become famous. Very early in his career, Gros had painted a highly acclaimed historico-mythological work, the beautiful and tenebrous *Sappho at Leucadia* [FIGURE 55], exhibited at the Paris Salon of 1801. This lyrical and poignant painting explores the desperate psychological state of the poet who was driven to suicide by her unrequited passion for Phaon (cf. pp. 59–60). The painting announced Gros's intention to establish himself as a reinterpreter of mythical themes (this was the very period in which many of David's students and followers were doing the same). But as one of the favorites of Napoleon and Josephine, Gros spent most of the Empire years working on commissions from Napoleon and his family. In addition to numerous portrait commissions from the imperial family, he was pressed into service to represent great moments of Napoleonic history, such as *Napoleon in the Pesthouse of Jaffa*, 1804, and *Napoleon at Eylau*, 1808.

Gros visited David several times in Brussels, and the two kept up a very active correspondence. As manager of David's atelier after his friend and

mentor went into exile, Gros continually received advice from his former teacher concerning historical or mythical compositions that he should undertake. David urged Gros to use the vehicle of history or myth to set his art in a new direction. We remember that David painted *Telemachus and Eucharis* as a conceptual pendant, a thematic antidote, to his disturbing *Amor and Psyche* of 1817. We might describe *Telemachus and Eucharis*, however, as a type of private pendant, for the paintings were purchased by different individuals and were linked principally in David's imagination. Because David wanted to help and encourage Gros, who seems to have suffered from serious depression after David went into exile, he engineered an official pendant for *Telemachus and Eucharis* to be painted by his devoted former pupil.[78] In so doing, David offered Gros a chance to be directly linked with him, thereby demonstrating publicly his supreme confidence and belief in Gros's artistic abilities.

In a long letter of June 22, 1820, David suggested possible subjects of mythical lovers that would accord well with the theme of Telemachus and Eucharis, including Daphnis and Chloe and Sappho and Phaon; he also sent along a drawing of the head of Telemachus from his painting so that Gros could paint figures in corresponding proportions, as would befit a pendant.[79]

One wonders what David thought of Gros's final composition, which does not accord well with David's interpretation of the theme of young love. Gros did make a pendant that resembles David's *Telemachus and Eucharis* in terms of the dimensions of the canvas and the compositional format: Like David, he placed the lovers in the immediate foreground, but he did not take David's advice in his choice of subject. *Bacchus and Ariadne*, which constitutes a rescue and a seduction, expresses a meaning very different from the tender and melancholy farewell of Telemachus and Eucharis. In a letter dated August 4, 1820, Gros wrote to David about his choice of subject and format, which had been accepted by the count von Schoenborn, but he emphasized that the theme gave him principally the opportunity to depict a female nude: "I realized that the pendant gave me the occasion to develop the torso of a woman."[80]

Gros's Ariadne is the antithesis, for example, of the melancholic, modest, grief-stricken heroine of Frémiet's composition. When seen alongside Frémiet's painting, and especially next to its pendant, David's *Telemachus and*

Eucharis, Gros's work seems strangely empty of significant content. His Ariadne is a seductive and coy temptress, who has attracted Bacchus, the god of wine, debauchery, and licentiousness. Unlike the modest, clothed, sorrowfully downcast Eucharis, Ariadne is presented in full-frontal nudity, and she appears to flirt openly and seductively with the spectator, to whom she presents herself with all of her female "charms" visible. She has very heavy eyelids, sensual eyes, and a pouting mouth. Bacchus is presented with very full, fleshy sensual facial features as well, and his corporal forms are equally ample and broad. The figures lean into one another, but in a way that differs dramatically from the configuration of Telemachus and Eucharis. Gros was concerned with the titillating representation of eroticism and lust. Bacchus rescues the beautiful, abandoned Ariadne because he is overcome with sexual desire. This is the very opposite, as we have seen, of David's intentions in his sympathetic and tender interpretation of the lovers Telemachus and Eucharis. Gros's subsequent mythological paintings of the 1820s are equally strange and similarly one-dimensional in terms of their content.[81]

Gros's letters to David from Paris concerning his teacher's mythological compositions reveal that he did not understand what David was trying to achieve in terms of stylistic and compositional innovations, nor did he understand the innovatory meanings of these experimental works.[82] Since painting *Sappho* early in his career, Gros had eschewed mythological themes. His late mythical works, initially given impetus by David's encouragement and especially by the commission from the count von Schoenborn, present empty conventions in terms of form and content. These late compositions are singularly uninspired and disturbingly devoid of the complex nexus of meanings we associate with the late mythological compositions of David and others of his students.

In spite of David's close rapport with his devoted pupil, he could not compel Gros to participate effectively in the renascence of mythical reinterpretation in the early nineteenth century. Ironically, it was another of David's former pupils, the celebrated artist Gérard, who, although he had become estranged from David, seemed best able to assimilate the mythical reforms of the exiled artist. One of Gérard's late masterpieces, *Daphnis and Chloe*, 1824 [FIGURE 56], is surprisingly akin to David's *Telemachus and Eucharis* in terms of its melancholy and lyrical presentation of tender and sympathetic adolescent lovers. It is likely, in fact, that

Figure 56
Baron François Gérard.
Daphnis and Chloe,
1824. Oil on canvas,
204 × 228 cm (80⅜ ×
89¾ in.). Paris, Musée
du Louvre (4740).
© Photo R.M.N.

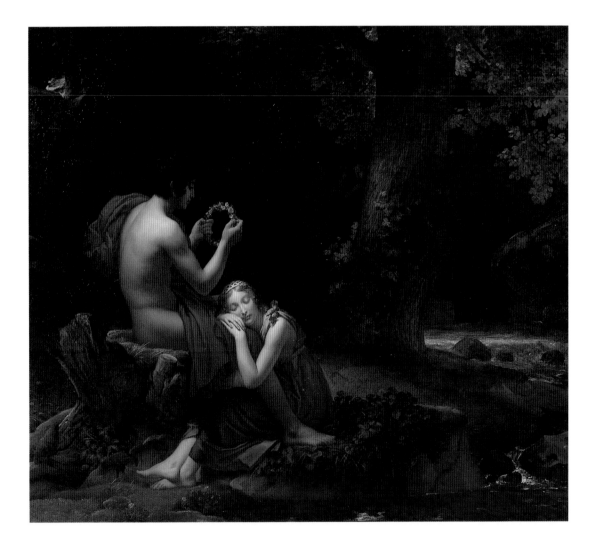

Gérard was directly inspired by David's composition, which he could have known from Frémiet's repetition, purchased by the French publisher Didot in 1822. Gérard had long-standing, direct connections with the Didot firm. Around 1800 he had worked on a lavishly illustrated edition of the French translation of Longus's Hellenistic romance *Daphnis and Chloe*, published by Didot. (We remember that Gérard created illustrations during the 1790s for the Didot edition of La Fontaine's *The Loves of Cupid and Psyche*, which had also led directly to a monumental painting of this theme.)[83] Gérard returned to the subject of Daphnis and Chloe in 1824, creating an original composition that was not to be found in his earlier illustrations, and that also diverges radically from earlier interpretations, such as that by Hersent [FIGURE 39]. In Gérard's painting, set in a mysterious, dark, and verdant wood that forms a type of grotto, Daphnis sits on the banks of a stream on a rock or tree stump with Chloe seated at his feet, their bodies intertwined. With her arms embracing him around the knees, she innocently sleeps while he looks down at her with love and tenderness, holding a crown of flowers, which he seems to hesitate to place on her head. Behind a magnificent tree in the right central background, three nymphs gravely dance.

Critics hailed the painting and used the same kind of language to describe it as they had for Hersent's *Daphnis and Chloe* of 1817 and David's *Telemachus and Eucharis* of 1818. The art critic Adolphe Thiers, who enthusiastically supported what he helped to define as the new "romantic" movement in art, acclaimed Gérard's depiction of the chaste and innocent lovers and tried to describe the depiction of the paradoxical "innocence" of the young couple that Gérard had successfully represented. The painting, he tells us, captures the charm, the mystery, delicacy, and melancholy of an adolescent love that is still pure. We are not to imagine that lust motivates the lovers; Chloe trusts Daphnis so completely that she is able to sleep in his presence and not fear for her virtue.[84] As we can see, like David's Telemachus, Gérard's Daphnis is a heroic, partially draped nude, while Chloe is very modestly dressed. And, like David, Gérard uses the graceful yet modest interlocking of the couple's corporal forms to express the union of their love and friendship. That this union is not yet sexually consummated is also suggested by Daphnis's hesitant gesture of holding tightly the crown of flowers above Chloe's head—the crowning of the lover was an emblem of inter-

course much in use from the eighteenth century onward. Daphnis seems to be meditating on this next stage of his relationship with Chloe, and the outcome of his reflections is not completely clear. Will he crown her with the garland of flowers while she innocently sleeps in a completely trusting way? The melancholy, somber, mysterious landscape setting seems to communicate the gravity of this liminal moment in the development of adolescent sexuality and love.

Many additional examples could be discussed that would reveal David's impact on the content and form of mythological paintings made in France and Belgium in the 1820s. In particular, *The Farewell of Telemachus and Eucharis* inspired a number of lyrical, melancholy depictions of hapless mythical lovers that emphasized the psychological dimensions of the narratives portrayed. David's intense exploration of mythological themes, so vividly epitomized in *The Farewell of Telemachus and Eucharis*, served, as we have seen, a catalytic role in the development of Romantic Hellenism. This fascinating painting, for so long consigned to critical oblivion, can now occupy its proper place in David's oeuvre and, indeed, in the canon of Romantic art.

All translations, which are as literal as possible, are by the author, unless otherwise noted.

1 I have discussed this in detail in D. Johnson, "Myth and Meaning: Mythological Painting in France circa 1800," in *Frankreich 1800: Gesellschaft, Kultur, Mentalitäten*, ed. G. Gersmann and H. Kohle (Stuttgart, 1990), 23–33. These ideas are further developed in D. Johnson, *Jacques-Louis David: Art in Metamorphosis* (Princeton, 1993), 236–72.

2 Beginning in the early 1980s, I focused attention on David's late works. See D. Johnson, "'Some Work of Noble Note': David's *La Colère d'Achille* Revisited," *Gazette des Beaux-Arts* (December 1984): 223–30; eadem, "Desire Demythologized: David's *L'Amour quittant Psyché*," *Art History* 9, no. 4 (December 1986): 450–70; eadem, *Jacques-Louis David* (see note 1), 236–72.

3 For a review of the historiography, see D. Johnson, *Jacques-Louis David* (note 1), 3–10.

4 For the most cogent account of these reforms, see R. Rosenblum, *Transformations in Late Eighteenth Century Art* (Princeton, 1967), 50–106.

5 D. Johnson, *Jacques-Louis David* (see note 1), 11–22.

6 Ibid., 112–20. And see especially, D. Dowd, *Pageant-Master of the Republic: Jacques-Louis David and the Revolution* (Lincoln, 1948), and M. Ozouf, *La fête révolutionnaire, 1789–1799* (Paris, 1976).

7 See D. Johnson, *Jacques-Louis David* (note 1), 77–90; and P. Bordes, "*Le Serment du Jeu de Paume*" *de Jacques-Louis David: Le peintre, son milieu et son temps, de 1789 à 1792* (Paris, 1983).

8 See the essay by A. Schnapper on Napoleon and David in his very important catalogue of the 1989 retrospective exhibition held in the Louvre, *Jacques-Louis David, 1748–1825* (Paris, 1989), 362–73.

9 "*Nous habitons une ville très hospitalière, dans laquelle, suivant ce que j'aperçois, j'y trouverai tous les agréments de la société. Mais je m'en abstiendrai le plus que je pourrai. J'aime, comme vous le savez, la vie méditative et je veux m'y livrer ici plus qu'ailleurs.*" This letter is preserved in the Ecole nationale supérieure des Beaux-Arts, ms. 316, no. 18, and is reproduced in D. and G. Wildenstein, *Documents complémentaires au catalogue de l'oeuvre de Louis David* (Paris, 1973), no. 1763, 202.

10 "*Je suis bien ici, j'y suis content, je n'y vois point ceux qui importuneraient mes yeux.*" This letter is reproduced in full in D. and G. Wildenstein, *Documents complémentaires* (see note 9), no. 1877, 219.

11 L. Hautecoeur, *Louis David* (Paris, 1954), 236–38.

12 "*Tous mes collègues rentrent en France; je serais certainement du nombre si j'avais la faiblesse de demander mon rappel par écrit. Vous connaissez votre père et la fierté de son caractère. Peut-il faire un pareil démarche? J'ai su ce que je faisais: j'avais l'âge pour savoir ce que je faisais. Je ne l'ai pas fait par passion. Le temps dévoilera la vérité . . . Ici j'ai le repos.*" This letter is preserved in the Ecole nationale supérieure des Beaux-Arts, ms. 316, no. 31, and is reproduced in full in D. and G. Wildenstein, *Documents complémentaires* (see note 9), no. 1841, 213.

13 *"Nous ne nous entendrons jamais, mon ami, tant que vous vous persuaderez qu'on ne peut être heureux qu'en France. Moi, je suis fondé à penser le contraire. Depuis mon retour de Rome, en 1781, je n'ai jamais cessé d'être persécuté, tourmenté dans mes travaux par tous les moyens les plus odieux et si le ciel ne m'avait pas favorisé d'une certaine force de tête, j'aurais pu y succomber. Laissez-moi jouir en paix du repos que j'éprouve en ce pays et qui m'a été inconnu jusqu'à présent."* This letter is preserved at the Ecole nationale supérieure des Beaux-Arts, ms. 316, no. 35, and is reproduced in part in D. and G. Wildenstein, *Documents complémentaires* (see note 9), no. 1855, 215.

14 D. Johnson, *Jacques-Louis David* (see note 1), 247–57, 260–63.

15 *"Ces ouvrages sont le fruit de la tranquillité d'esprit que je partage avec les heureux habitants ce cet empire."* Cited in Hautecoeur, *Louis David* (see note 11), 256, and published in part in D. and G. Wildenstein, *Documents complémentaires* (see note 9), no. 1847, 214. David's letter was published in the Belgian newspaper *L'Oracle* (July 7, 1819): 4.

16 See D. Johnson, *Jacques-Louis David* (note 1), 232–36.

17 Discussed in the exhibition catalogue *Jacques-Louis David, 1748–1825* (see note 8), 540.

18 Ibid., 513–16. See also D. Johnson, *Jacques-Louis David* (note 1), 222.

19 Ibid., 200–4.

20 *"Je m'occupe beaucoup de mon art, la santé favorise mes succès et si j'en crois ce que l'on ne cesse de me répéter, jamais je n'aurais fait de meilleurs ouvrages et plus décidément dans le goût simple et énergique de l'antique Grèce."* This letter is preserved in the Ecole nationale supérieure des Beaux-Arts, ms. 316, no. 31, and is reproduced in full in D. and G. Wildenstein, *Documents complémentaires* (see note 9), no. 1841, 213.

21 *"C'est mon dernier adieux à la peinture."* David wrote this to Gros in a letter dated October 21, 1823, preserved in the Ecole nationale supérieure des Beaux-Arts, ms. 316, no. 50.

22 D. Johnson, *Jacques-Louis David* (see note 1), 246–54.

23 D. Johnson, "Desire Demythologized" (see note 2).

24 Ibid.

25 D. Johnson, "'Some work of noble note'" (see note 2).

26 *". . . enfin ne consultant que mon amour pour mon art, je me suis lancé de nouveau dans la grande carrière d'un plus grand style historique. Je me suis avisé de peindre des Dieux, nouveau titan, j'ai osé pénétrer dans leur demeure; puisse-je ne pas être foudroyé comme eux."* This letter is preserved in the Bibliothèque des Musées nationaux, ms. 310, f. 223. Cited in part in *Jacques-Louis David, 1748–1825* (see note 8), 630.

27 D. Johnson, *Jacques-Louis David* (see note 1), 260–72.

28 Documented in *Jacques-Louis David, 1748–1825* (see note 8), 526. Through a study of letters and related documents, Helmut Engelhart has investigated the circumstances surrounding the purchase of *The Farewell of Telemachus and Eucharis* and the early history of its fortunes as well as its rapport with Sophie Frémiet's repetition; see "The Early History of Jacques-Louis David's *The Farewell of Telemachus and Eucharis*," *The J. Paul Getty Museum Journal* 24 (1996).

29 David's response to this charitable request was published in *L'Oracle* (July 8, 1818).

30 See A. Schnapper, "David et l'argent," in *David contre David: Actes du colloque organisé au musée du Louvre par le service culturel du 6 au 10 décembre 1989,* ed. R. Michel (Paris, 1993), 2: 909–26.

31 J. Odevaere's review was published in *L'Oracle* (July 6, 1818): 3–4.

32 I am indebted to conservationist Mark Leonard of the J. Paul Getty Museum, who spent a full afternoon sharing with me the discoveries made through his various technical analyses of the painting. He subsequently sent me a full set of detailed slides he had made in the course of his restoration.

33 I would like, again, to thank Mark Leonard for so generously sharing his discoveries with me.

34 *Jacques-Louis David, 1748–1825* (see note 8), fig. 150, 526.

35 These images have recently been studied by A. Solomon-Godeau, "Male Trouble: A Crisis in Representation," *Art History* 16, no. 2 (1993): 286–310. For a discussion of depictions of the adolescent body during the French Revolution, see A. Potts, "Beautiful Bodies and Dying Heroes: Images of Ideal Manhood in the French Revolution," *History Workshop* (autumn 1990): 1–21, and also idem, "De Winckelmann à David: L'incarnation des idéaux politiques," in *David contre David* (see note 30), 2: 647–70.

36 Homer, *The Odyssey*, trans. R. Fitzgerald (New York, 1990).

37 François de Salignac de La Mothe-Fénelon, *Les Aventures de Télémaque* (Paris, 1699).

38 N. Cornelissen, "Eucharis et Télémaque," *Annales belgiques des sciences, arts et littératures* (Ghent, 1818), 2: 383–98; 2: 23–34.

39 "*Fénelon . . . nous montra le Télémaque promis par Homère. Eucharis appartient toute entière au pinceau de Fénelon; mais quelques traits aussi indiquent plutôt les contours de l'image qu'ils ne la fixent sur la toile.*

Le pinceau de David, inspiré par le génie de Fénelon et d'Homère, a réuni ces traits
épars, et voici Eucharis *une seconde fois à côté de Télémaque;—Eucharis belle de pudeur de l'amour!*—Télémaque, *fils du divin Ulysse dont il a la douceur et la fierté avec la taille et la démarche majestueuse*" (emphasis in original). Ibid., 2: 384.

40 "*Je n'ai pas encore dit adieu à Eucharis.*" Ibid., 1: 386.

41 "*C'est parce que le chaste ouvrage de Fénelon a pour but d'inspirer une aversion raisonnée pour la volupté, qu'il indique nulle part que les jeunes amans aient connu, un seul instant, les plaisirs de l'amour heureux, tranquille et satisfait; toujours le peintre nous les livre souffrans et les dévoue à notre pitié. 'Eucharis brule d'un feu plus cruel que toutes les douleurs de la mort . . . Télémaque souffre; sa douleur est mêlée de honte; il verse des larmes amères; sa beauté, son enjouement, sa noble fierté s'enfuient loin de lui. Il périt telle qu'une fleur; ses vives couleurs s'effacent et sa belle tête se penche!* Tel est le coloris de l'écrivain. Tel ne sera pas celui du peintre qui doit parler à nos yeux, communiquer par nos yeux à notre âme les sensations qu'il veut exciter en nous, ou nous faire partager; il nous montrera donc son Télémaque souffrant sans doute, combattu sans doute par des passions contraires, mais toujours paré de jeunesse et de vigueur, toujours divin, toujours beau comme un Dieu*" (emphasis in original). Ibid., 1: 385–86.

42 Ibid., 1: 390.

43 "*Cette* Eucharis *qui, rougissant d'elle-même, a baissé ses grands yeux . . . ses traits sont empreints d'innocence et de chasteté . . .* le pinceau de David, *chaste comme la pensée de Fénelon, n'a voulu nous montrer des caresses de la volupté que ce qu'elles offrent d'innocent. Une soeur désolée n'essaierait pas autrement de retenir un frère qu'elle chérit. . . . La figure* d'Eucharis *indique la jeunesse d'une vierge*" (emphasis in original). Ibid., 1: 390–91.

44 Ibid., 2: 25–30.

45 *"Le buste offre cette nudité héroïque qui pare avec une si noble décence, les guerriers d'Homère et les demi-dieux de la Grèce."* Ibid., 2: 30.

46 La Font de Saint-Yenne, *Sentimens sur quelques ouvrages de peinture, sculpture et gravure écrits à un particulier en Province* (n.p., 1754), 65–69.

47 One can follow the changes in mythological subjects from the 1750s and 1760s to the 1770s and 1780s in C. Bailey, *The Loves of the Gods: Mythological Painting from Watteau to David* (New York, 1992).

48 For a discussion of this burgeoning discourse on myth, see D. Johnson, "Myth and Meaning: Mythological Painting in France circa 1800," in *Frankreich 1800: Gesellschaft, Kultur, Mentalitäten*, ed. G. Gersmann and H. Kohle (Stuttgart, 1990), 23–33.

49 *"En 1787 il fit pour le ci-devant comte d'Artois un tableau représentant les amours de Pâris et d'Hélène. Il ne s'était pas encore exercé [biffé: essayé] dans cette sorte de genre agréable. Il ne fit pas de cet agréable que l'on avait vu jusqu'alors et le fit à la manière grecque et tout à fait antique. Il étonna ceux qui doutaient de ses succès dans le genre et les éloges qu'il lui en firent attestent la réussite de l'ouvrage."* "Autobiographie de David," April, 1793, preserved in the Ecole nationale supérieure des Beaux-Arts, ms. 323, no. 3, and published in P. Bordes, *"Le Serment du Jeu de Paume"* (see note 7), 174–77.

50 E. Coche de la Ferté and J. Guey, "Analyse archéologique et psycholanalytique d'un tableau de David: *Les Amours de Paris et d'Hélène*," *Revue Archéologique* 40 (1952): 129–61.

51 See D. Johnson, "Myth and Meaning" (note 1).

52 The most comprehensive study of this painting is by J. H. Rubin, "Endymion's Dream as a Myth of Romantic Inspiration," *Art Quarterly* (spring 1978): 47–84. See also most recently, T. Crow, *Emulation: Making Artists for Revolutionary France* (New Haven, 1995), 133–39.

53 See D. Johnson, "Myth and Meaning" (note 1).

54 Ibid.

55 *"N'approchez point, vous dont l'âme aride et flétrie ignore ce charme tout-puissant et céleste attaché à l'aimable pudeur, au respect timide et religieux, à tout ce mélange ineffable de désirs et de retenue dont se compose le véritable et pure volupté! Ce beau corps est voilé de décence. . . . C'est une jeune fille simple, candide, vertueuse, ingénue; mais où est la volupté? Ne la voyez-vous point dans son innocence?"* La Décade philosophique, littéraire et politique 18 (an vi [1798]): 335–36.

56 *"Quelle grâce! quelle pudeur! quelle innocence! Ah! qui que vous soiés, ne troublés pas ses amans. laissés moi jouir de cette brillante aurore, de cet épanouissement d'un coeur virginal"* (Such grace! Such modesty! Such innocence! Ah! Whoever you may be, do not bother these lovers. Let me enjoy this radiant dawn, this unfolding of a virginal heart). *Mercure de France*, Collection Deloynes 19, no. 538 (1798): 12–13.

57 *"C'est, si je ne me trompe, l'instant de passage de l'adolescence à la jeunesse que le peintre a voulu nous reveler."* *Journal de Paris*, Collection Deloynes 19, no. 532 (1798): 702–5.

58 *"Telle est l'innocente simplicité de ces deux figures, que leur nudité, au premier aspect, n'a rien de contraire à la pudeur."* *Journal de Paris* (May 30, 1817): 3.

59 *"Elles sont nues et respirent l'innocence. Leur âme se peint dans leurs attitudes, comme sur leurs visages. Le groupe est aussi bien disposé pour l'effet pittoresque qu'ingénieusement conçu pour exprimer l'affection réciproque des deux jeunes amans."* *Le Moniteur Universel* (May 21, 1817).

60 *"Un pendant à ma Psyché."* David's letter
to Van Brée of October 20, 1817, is pre-
served in the Ecole nationale supérieure
des Beaux-Arts, ms. 316, no. 25.

61 *"Affligeant"; "cet empire d'une nature igno-
ble sur l'idéalisme; il contriste, il serre
le coeur."* A. de Kératry, *Annuaire de l'école
française de peinture; ou, Lettres sur
le Salon de 1819* (Paris, 1820): 100–1.

62 *"Ici il n'y a point de dieu; il n'y en eût jamais.
Il n'est pas de femme qui ne fût éffrayée
à l'aspect de l'être qui en usurpe la place.*

*Dans cette scène où une nature grossière
triomphe et se joue des plus douce émotions
accordées à la vie, le coeur se serre; il se
sent oppressé d'un poids accablant. La pensée
se replie sur elle-même, elle s'interroge et
elle se demande avec amertume, si le bonheur
promis ici-bas, et dont une bonté compatis-
sante entremêla quelquefois nos peines, n'est
autre chose que la misérable parodie offerte
par le pinceau de M. David."* A. H. Kératry,
Du beau dans les arts d'imitation (Paris,
1822), 1: 97–98.

63 *"La tête de l'Amour est d'un caractère un peu
faunesque, les mains un peu brunes et surtout
pas assez blaireautés."* Gros's letter to
David is preserved in the Ecole nationale
supérieure des Beaux-Arts, ms. 316,
no. 26. In *Essai sur les Beaux-Arts, et par-
ticulièrement sur le Salon de 1817* (Paris,
1817), 237–38, E. F. A. M. Miel wrote,
*"Cet Amour n'est point un dieu, ce n'est
même pas un bel adolescent; c'est le modèle,
un modèle commun, copié avec une exacti-
tude servile, et en qui l'expression du bon-
heur n'est qu'une grimace cynique."*

64 *"M. David n'a pas encore adhéré à la critique
qu'on a faite de l'Amour . . . il évoque le
jugement de l'avenir pour fixer le rang que
doit occuper cette production."* See *Notice
sur la vie et les ouvrages de M. J.-L. David*
(Paris, 1824), 68. Cited in *Jacques-Louis
David, 1748–1825* (see note 8), 519.

65 See P. Spencer-Longhurst, *"Apelles Paint-
ing Campaspe* by Jacques-Louis David:
Art, Politics and Honour," *Apollo* (March
1992): 157–63.

66 *Jacques-Louis David, 1748–1825* (see
note 8), 485.

67 E. Delécluze, *Le Lycée français* (Paris,
1819), 2: 76–78.

68 *"Aujourd'hui je veux qu'on me peigne
l'amour dégagé de tous les embarras de la vie
civilisée. . . . Je veux qu'on me donne l'idée
de l'amour comme on l'imagine quand on n'a
que seize ans, sans tourmens, sans embarras.
Je vous l'avoue, c'est dans ces occasions où
il me semble que la mythologie seule sait
correspondre avec mon imagination, et a le
privilège de réveiller chez moi des sensations
fugitives comme l'âge qui les avait fait
naître."* Ibid., 77–78.

69 Ibid., 75–76.

70 J. H. Rubin, "Pygmalion and Galatea:
Girodet and Rousseau," *The Burlington
Magazine* 27 (August 1985): 517–20.

71 D. Coekelberghs and P. Loze, *1770–1830:
Autour du néo-classicisme en Belgique*
(Brussels, 1985), 230–39.

72 D. Johnson, *Jacques-Louis David* (see
note 1), 261–62. See especially Angélique
Mongez's letter to David concerning *Mars
Disarmed by Venus and the Graces*, pre-
served in the Ecole nationale supérieure
des Beaux-Arts, ms. 318, no. 65.

73 C.-P. Landon, *Annales du Musée et de
l'Ecole Moderne des Beaux-Arts* (Paris,
1808), 1: 90–92.

74 Coekelberghs and Loze, *1770–1830*
(see note 71), 252–54. See also note 28.

75 Ibid., 253–54, fig. 223.

76 *" . . . son génie, qui, suivant la psychologie
Platonique, est l'arbitre souverain de sa
conduite, le témoin assidu de ses actions, le
confident de ses plus secrètes pensées, est ici
représenté comme le symbole de son infortune*

et renverse, sans l'éteindre, le flambeau d'un amour malheureux." Ibid., 254. The description first appeared in *Explication des ouvrages de peinture, sculpture, gravure, architecture, etc. des artistes vivans, exposés au musée de l'académie* (Ghent, 1826), 15.

77 See in particular the letters preserved in the Ecole nationale supérieure des Beaux-Arts, ms. 316, no. 50; ms. 318, nos. 34, 65.

78 Cited in D. and G. Wildenstein, *Documents complémentaires* (see note 9), no. 1877, 219.

79 *Jacques-Louis David, 1748–1825* (see note 8), fig. 50.

80 "*J'ai vu que le pendant me donnait à développer un torse de femme,*" ibid., 526–27. The letter is preserved in the Ecole nationale supérieure des Beaux-Arts, ms. 318, no. 31.

81 See especially, T. Gaehtgens, "Bacchus and Ariadne, by Antoine-Jean Gros," *Annual Bulletin of the National Gallery of Canada* 2 (1978–79): 62–79; and also J.-B. Delestre, *Gros: Sa vie et ses ouvrages*, 2nd edn. (Paris, 1867), 229–31, 372.

82 See the letters preserved in the Ecole nationale supérieure des Beaux-Arts, ms. 316, no. 26; ms. 318, no. 34.

83 Gérard's illustrations for Daphnis and Chloe are discussed by M. Moulin, "*Daphnis et Chloé* dans l'oeuvre de François Gérard (1770–1837)," *Revue du Louvre* 2 (1983): 100–9.

84 A. Thiers, in *Le Globe* (February 15, 1825).

BIBLIOGRAPHY

BAILEY, COLIN B.
 The Loves of the Gods: Mythological Painting from Watteau to David. New York: Rizzoli, 1992.

BRA, T.
 "Tableau de David." *Feuilleton littéraire* 88 (Friday, May 28, 1824): 2.

BROOKNER, ANITA
 Jacques-Louis David. London: Chatto & Windus, 1980.

BRYSON, NORMAN
 Tradition and Desire: From David to Delacroix. New York: Cambridge Univ. Press, 1984.

COEKELBERGHS, DENIS, and PIERRE LOZE
 "David à Bruxelles et la peinture en Belgique." In *David contre David: Actes du colloque organisé au musée du Louvre par le service culturel du 6 au 10 décembre 1989*, edited by Régis Michel, 1047–65. Paris: Documentation française, 1993.

———, eds. *1770–1830: Autour du néo-classicisme en Belgique*. Brussels: Crédit Communal, 1985.

CORNELISSEN, N.
 "Eucharis et Télémaque." *Annales belgiques des sciences, arts et littérature* (Ghent, 1818): 1: 383–98; 2: 23–34.

COUPIN, PIERRE ALEXANDRE
 Essai sur J.-L. David, Peintre d'histoire. Paris: J. Renouard, 1827.

CROW, THOMAS E.
 Emulation: Making Artists for Revolutionary France. New Haven: Yale Univ. Press, 1995.

———. *Painters and Public Life in Eighteenth-Century Paris*. New Haven: Yale Univ. Press, 1985.

———. "*The Oath of the Horatii* in 1785: Painting and Pre-Revolutionary Radicalism in France." *Art History* (December 1978): 424–71.

DAVID, J.-L. JULES
 Le Peintre Louis David, 1748–1825: Souvenirs et documents inédits. 2 vols. Paris: V. Havard, 1880.

David contre David: Actes du colloque organisé au musée du Louvre par le service culturel du 6 au 10 décembre 1989, edited by Régis Michel. 2 vols. Paris: Documentation française, 1993.

DELÉCLUZE, ETIENNE
 Louis David, son école et son temps: Souvenirs. Paris: Editions Macula, 1983.

———. *Le Lycée français*. Paris, 1819.

DOWD, DAVID LLOYD
 Pageant-Master of the Republic: Jacques-Louis David and the Revolution. Lincoln: The University, [1948].

FOISSY-AUFRÈRE, MARIE-PIERRE, et al.
 La Mort de Bara: De l'évènement au mythe: Autour du tableau de Jacques-Louis David. Avignon: n.p., 1989.

GAEHTGENS, THOMAS W.
 "Bacchus and Ariadne, by Antoine-Jean Gros." *Annual Bulletin, National Gallery of Canada* 2 (1978–1979): 62–79.

GERSMANN, GUDRUN, and HUBERTUS KOHLE, eds.
 Frankreich 1800: Gesellschaft, Kultur, Mentalitäten. Stuttgart: F. Steiner, 1990.

HAUTECOEUR, LOUIS
 Louis David. Paris: La Table ronde, [1954].

Jacques-Louis David, 1748–1825. Exh. cat. Paris: Réunion des musées nationaux, [1989].

Janson, Anthony F.
"The Sources of David's 'Anacreon Paintings.'" *Source: Notes in the History of Art* 3 (fall 1983): 19–22.

Johnson, Dorothy
Jacques-Louis David: Art in Metamorphosis. Princeton: Princeton Univ. Press, 1993.

———. "L'expérience d'exil: L'art de David à Bruxelles." In *David contre David: Actes du colloque organisé au musée du Louvre par le service culturel du 6 au 10 décembre 1989*, edited by Régis Michel, 2: 1025–46. Paris: Documentation française, 1993.

———. "Corporality and Communication: The Gestural Revolution of Diderot, David and the *Oath of the Horatii.*" *The Art Bulletin* 71 (March 1989): 92–113.

———. "Desire Demythologized: David's *L'Amour quittant Psyché.*" *Art History* 9, no. 4 (1986): 450–70.

———. "'Some Work of Noble Note': David's *La Colère d'Achille* Revisited." *Gazette des Beaux-Arts* (December 1984): 223–30.

Kohle, Hubertus
"Der Tod Jacques-Louis Davids: Zum Verhältnis von Politik und Ästhetik in der französichen Restauration." *Idea: Jahrbuch der Hamburger Kunsthalle* 10 (1991): 127–53.

Lebensztejn, Jean-Claude
"Histoires belges." In *David contre David: Actes du colloque organisé au musée du Louvre par le service culturel du 6 au 10 décembre 1989*, edited by Régis Michel, 1011–24. Paris: Documentation française, 1993.

Lenoir, Alexandre
"Mémoires, David, Souvenirs historiques." *Journal de l'Institut historique* 3 (1835).

McPherson, Heather
"*The Fortune Teller* of 1824, or, The Elegant Dilemma of David's Late Style." *Gazette des Beaux-Arts* (July–August 1991): 27–36.

Michel, Régis
David: L'Art et le politique. [Paris]: Découvertes Gallimard: Réunion des musées nationaux, 1988.

Miette de Villars, M.
Mémoires de David, peintre et député de la Convention. Paris: [s.n.], 1850.

Notice sur la vie et les ouvrages de M. J.-L. David. Paris: Dondey-Dupré père et fils, 1824.

Regards sur Amour et Psyché à l'âge néo-classique. Exh. cat. Zurich: Musée de Carouge, 1994.

Roberts, Warren E.
Jacques-Louis David, Revolutionary Artist: Art, Politics, and the French Revolution. Chapel Hill: Univ. of North Carolina Press, 1989.

Rosenblum, Robert
Transformations in Late Eighteenth Century Art. Princeton: Princeton Univ. Press, 1967.

———. "Jacques-Louis David's 'Telemachus and Eucharis.'" *Sotheby's Preview*, no. 68 (January/February 1987): 4–5.

———. "Jacques-Louis David's 'Farewell of Telemachus and Eucharis.'" *Sotheby's Art at Auction 1986–1987* (London, 1987): 80–85.

Schnapper, Antoine
"Après l'exposition David: La Psyché retrouvée." *La Revue de l'Art* 91 (1991): 60–66.

———. *David, témoin de son temps.* Fribourg: Office du Livre, 1980.

Sérullaz, Arlette
Dessins de Jacques-Louis David, 1748–1825. Inventaire général des dessins, Ecole française. Musée du Louvre. Paris: Réunion des musées nationaux, 1991.

———. "Dessins de Jacques-Louis David." *Revue du Louvre*, supplément (1979): 100–4.

———. "A propos de quelques dessins de Jacques-Louis David pour *Mars désarmé par Vénus et les Grâces.*" *Bullétin des Musées Royaux des Beaux-Arts de Belgique* 21.1/4 (1972–75): 107–16.

SPENCER-LONGHURST, PAUL
"*Apelles Painting Campaspe* by Jacques-Louis David: Art, Politics and Honour." *Apollo* (March 1992): 157–63.

SUE, JEAN JOSEPH
"Rapport sur les tableaux de David, lu à la séance publique du 5 mai." *Journal du Lycée des Arts* 3 (May 13, 1793): 9–13.

THIERS, ADOLPHE
"De Monsieur David et de son dernier tableau." *Revue européenne* (June 1, 1824): 335–39.

TH[OMÉ DE GAMOND], A[IMÉ].
Vie de David: Premier peintre de Napoléon. Brussels: H. Tarlier, 1826.

VERBRAEKEN, RENÉ
Jacques-Louis David jugé par ses contemporains et par la postérité. Paris: L. Laget, 1973.

WILDENSTEIN, DANIEL, and GUY WILDENSTEIN
Documents complémentaires au catalogue de l'oeuvre de Louis David. [Paris]: Fondation Wildenstein, [1973].